# The Sinsemilla Technique

# The Sinsemilla Technique

an insight into a
cultivation production
technique

## by Kayo

## Last Gasp Publications

Cover Photograph:

## CUTTING IN ENVIRONMENT

This cutting, as I was told, was taken from a very special *Cannabis indica* plant growing in the hills of Northern California. It was placed in a solution of indoleacetic acid to stimulate root growth, then covered with a plastic bag to reduce its need for water. It was then transported to a propagation laboratory near San Francisco, where it would become the mother plant for many new cuttings of that very special plant.

Published by The Last Gasp of San Francisco

Note: This text is an attempt to present a
reasonable insight into a cultural,
agricultural and economic phenomenon.
The author, producers, and publisher do
not advocate breaking the law.

All photographs by Kayo (unless otherwise credited).

Produced, designed, and illustrated by
TS Productions, Santa Cruz, California.

Assistant Paste-Up / Little Wing Studio
Typesetting / Lighthouse Graphics
ISBN 0-86719-303-4

Printed in Hong Kong.

14   13   12   11   10

For:

Harry Anslinger
Commissioner, Federal Bureau of Narcotics
1892—1975

and

Dennis (Rabbit) Johnson
Cultivator
1947—1978

# CONTENTS

## ACKNOWLEDGEMENTS

I am indebted to those individuals who allowed me access to their secret gardens. Without their trust, this book would be but a dormant seed. While I cannot mention their names, I do want to extend them my deepest gratitude for opening the garden gates.

In addition, I would like to thank those individuals who contributed time and expertise to the publication of this book. Without your help, *The Sinsemilla Technique* would be but scribbles on a legal pad.

And of course, I would like to thank Mrs. Kayo, for driving all those miles, assisting with all of those photographs, reading all that text, designing, illustrating, and building this book, and above all, for being my sound-person.

# Introduction

*The Sinsemilla Technique* is about a method of cultivating plants in adverse environments. Today, the technique is employed almost exclusively in the production of cannabis. In the near future, it will be employed in the production of food.

Sinsemilla (sin seh ME ya) is Spanish for "without seeds." Through its association with marijuana—a Spanish word for *Cannabis sativa L.*—sensimilla has worked its way into the English vocabulary. One hears it in the language of the street—the colloquial communication of friends.

As a raw term, the connotations of sinsemilla vary. There are three categories of meaning for the word. These categories reflect different relationships with cannabis, and as such, are the perspectives of special interests.

For the estimated 22 million American consumers, sinsemilla has become a synonym for "quality."

Cannabis is consumed for the effects of a chemical called Delta 9-Tetrahydrocannabinol (THC). Consumers, quite naturally, prefer a product that has a high percentage of THC and a low percentage of extraneous plant matter. Domestic varieties of cannabis are produced without seed and, in general, have been increasing in THC content from year to year. The seedless flower enables consumers to get more of what they pay for and, as a result, has become a popular form of the cannabis product.

As the popularity of cannabis escalated, consumers adopted sinsemilla as the generic name for all THC-potent strains of cannabis produced without seeds. Through this continued word-of-mouth association, the term sinsemilla developed the connotation of quality—a feeling reinforced by black-market prices.

For Delegated Authority, the term sinsemilla connotes "problems."

This connotation is illustrated in a circular entitled *Sinsemilla: Public Awareness Program,* published by the California Attorney General's Office: "Sinsemilla is a new type of marijuana that, since 1976, has risen to the top of the drug line.... It's what's happening.... The most abused illegal drug in the United States is marijuana . . . the legislature has made the commercial possession, cultivation, and sales of marijuana a felony."

Three to five billion dollars are spent annually on the enforcement of this definition. In some cases efforts to eradicate cannabis have proved successful. One such effort—spraying the herbicide paraquat on producing farms in Mexico—so unnerved consumers that they simply refused to purchase any cannabis from that section of the world. In other situations eradication efforts have encountered resistance. As the government circular complains: "Notwithstanding this prohibition, clandestine Sinsemilla cultivation and distribution pose unique problems for law enforcement. . . . "

Where sinsemilla is perceived by one group to be a quality product, and by another group to be a felony transgression, a confrontation occurs. From this confrontation energy is produced. For clandestine cultivators of cannabis, the energy of conflicting values is synonymous with "opportunity."

Cultivators define sinsemilla as a production technique. This technique is relatively simple: The greatest concentration of THC is found in the resin bracts of the female cannabis flower. Left untended, the female plant will expend 40% of her life-force on the production of viable seeds. By removing the male plant before pollination, metabolism is directed into the continued production of flowers. This manipulation enables cultivators to harvest more THC-bearing flowers while growing fewer plants in smaller gardens.

This production technique evolved in response to a problem intrinsic to Modern Times: How can one produce more substance value—in this case THC—with fewer resources? For this reason, sinsemilla developed the connotation of "opportunity" for cultivators throughout the United States.

This writer became intrigued with the concept of sinsemilla while examining an ounce of cannabis from Columbia. This ounce—the six-pack of the consumer underground—consisted of decayed flowers, sticks, clods of earth, and thousands of healthy seeds. It had the bouquet of barn-yard dung, and the appearance of having traveled thousands of miles in the hold of a rusty freighter.

As a product of the 1970's, the "Columbian" was a good representative of the marketplace: It was produced with foreign labor and purchased with cheap money. But while the substance lacked the value of quality, it had potential; or so this writer thought, as the seeds cascaded from the ounce bag.

In the following years, I traveled tens of thousands of miles, following the progress of seeds from foreign lands. On the road I found it necessary to develop research skills. There was, for example, the need to make impertinent requests

of friends: "Show me your garden." Once inside the garden, there was the need to ask for more: "Now stand next to this plant, and turn away from the camera."

While favor opened the gates of friends, there were rumors of large plantations hidden on suburban slopes in the sunny southwest, large greenhouses nestled among the clear-cut forests of Oregon, and basements filled with 1000 watt lights in the rain-drenched northwest. For tickets to these events, I appealed to the individual's sense of pride—a vulnerability to which cultivators are particularly susceptible.

To grow any crop, one must be attentive to the physical and political conditions of the environment. Negligence in this respect might easily result in the loss of a crop. Since the cultivation of cannabis is a felony transgression, cultivators must be especially attentive because their personal well-being, as well as their crop, is at risk.

To encourage the success of these gambles, cultivators do not advertise their skills around the neighborhood. These skills are camouflaged within normal day-to-day routines. Indeed, cultivators struggle mightily to appear normal and unremarkable to the neighbors down the road.

Appearances notwithstanding, cultivators invest a good deal of time and energy on the secret gardens. They represent, after all, the hope for the future. For that reason, the gardens are physical manifestations of personality and accurate measurements of character. Like all farmers, cultivators of cannabis take pride in their hard work. Unlike other farmers, cultivators must camouflage both their gardens and their pride. Keeping a secret is a remarkable task in itself, but when the secret is a beautiful garden—the result of long hours of hard work—the task is nearly impossible. This pride is the cultivator's vulnerability.

Through the knowledge of this Achilles' heel and the discriminate use of hospitality, I was given a certain degree of latitude and eventually a name suitable for traveling the secondary highways of the west. The appellation came as an acronym—of sorts—scribbled in pencil on the side of a grocery sack full of leaves: "Okay, Kayo."

In the years it took to explore these byways, the opportunity generated by the confrontation of values developed into a phenomenon of immense proportions. Estimates place the yield of the recent harvest at between 8 and 10 billion dollars; making cannabis the fourth largest agriculture crop in the United States behind corn, soybeans, and wheat. This crop was produced by 1 to 2 million cultivators on what could best be described as agriculturally marginal land.

*The Sinsemilla Technique* is an attempt to present a reasonable, if impressionistic, insight into the phenomenon of this homegrown crop. As an insight it strives to provide a service to the curious. For the purpose of this discussion, the curious are considered to be those who, in one way or another, participate in the phenomenon.

In the United States there are two levels of participation: One is either a

consumer or a producer. In some respects, the situation resembles a professional sporting event.

Those who purchase cannabis for personal consumption—or who finance eradication campaigns through taxes—have a passive participation in the event. For the price of admission, they receive stimulation from the activity occurring on the playing field. In this sense they are consumers.

Those who cultivate cannabis—or keep it from being cultivated—have an active participation in the event. For wage or salary, they conduct the drama of struggle back and forth across the playing field. In this sense they are producers.

Unlike attendance at professional sporting events, participation in the phenomenon of home-grown cannabis is mandatory. All tax-paying citizens, in one way or another, have purchased tickets—and are in need of a program. The information included in this program will familiarize the participants with the language of the event, the nature of the confrontation, and of the activity on the playing field.

For *The Sinsemilla Technique* to be of service, it must yield rational information. There are, however, historical—and hysterical—aspects to the cannabis-related environment which make any attempt to be reasonable a difficult proposition.

While substantial in volume, cannabis-related information seems to reflect the intoxicating nature of the substance itself. Often called "Reefer Madness" after a 1930's educational film, cannabis-related propaganda is a manifestation of confrontation. Consider the intensity of this Harry Anslinger insight (vintage 1937): "The marijuana user is a violent criminal, with an insatiable appetite for rape, homicide, and mayhem. Eventually it renders the user totally insane."

While this insight might seem a relic of the past, it is, nevertheless, indicative of most cannabis-related information. Noted authorities are polarized on one side of the issue or the other. While the information they yield may serve to enforce a preconceived notion, sway public opinion, and pass legislation, it does not encourage rational consideration by an informed public. The result of this confrontation is decades of high-voltage hyperbole which encourages emotional reaction rather than rational contemplation.

In addition, the energy of conflicting values creates unusual hybridizations of character among the participants in the phenomenon of homegrown cannabis. While the cultivators are society's bad players, and Delegated Authority society's good players, the conflict creates situations in which bad is good, and good is bad. Like propaganda, these confusing roles affect the flow of information and distort perception. For example, consider the cultivators:

One aspect of the cultivators' work is that of farmer. Throughout recorded time farmers have, as a group, become known as having characters strong in virtue and neighborliness, a result of having a crop in the field which is subject to the whims of God and man alike. It is an extremely vulnerable position, whether

the crop is cannabis or feed corn. Because of this vulnerability farmers tend to be God-fearing people who value good neighbors. As Thomas Jefferson said in a letter to a friend: "Corruption of morals in the mass of cultivators is a phenomenon of which no age nor nation has furnished an example."

Yet the other aspect of the cultivators' character is that of outlaw. Through breaking the law, cultivators assume the strong emotional pressures associated with being a fugitive. In the autumn, when the Eradication Teams and thieves are most active, these pressures can become overwhelming. As one grower— recovering from "Black Friday" in the hills of Mendocino—said: "Growing sinsemilla is a militaristic operation with zealous religious overtones."

This hybridization of character is inherent in the "good" players as well as the "bad." The rural deputy sheriff, for example, provides an important service to citizens by maintaining the health of their community. Through constant supervision the deputy controls the level of illegal cultivation activity. Without this service small, individual-sized plots of cannabis could easily grow into large, commercial-scale plantations. For large operations to be successful, large organizations of people are necessary to do the labor. These organizations are less likely to be concerned about the health of a community than the potential for profit. Through supervision the deputy can keep these organizations from forming and thereby fulfill his responsiblility to the citizens.

On the other hand, an overzealous approach to duty can result in a lot of red ink on the citizens' ledgers. By prosecuting all illegal activity, the deputy might easily incinerate a neighborhood's principle source of income and fill the jails and courts with criminals and costly proceedings. Citizens must pay for this prosecution three times. First, there is the direct cost of the deputy's wage, equipment, and organization. Second, there is the cost of incarceration and prosecution. And third, there is the cost of losing a product which brings money into the community. This kind of red ink affects law abiding merchants as well as outlaw growers. Ultimately, it can diminish the deputy's ability to maintain community health. As one deputy, whose territory includes California's Big Sur, related: "Since I became a member of this Marijuana Eradication Team, I have lost my sources of information. People just quit talking to me."

The decades of hyperbole, together with the hybridization of "good" personality traits with "bad," have created an intellectual environment which resembles, in character, the fall of Saigon, as seen on the network news. Objective information on the phenomenon of cannabis is non-existent. There is no reason; there are no facts. One segment of the population considers cannabis a threat, and another segment considers it a blessing.

This confrontation is an American institution. Becoming involved in the debate is like going to the ballpark on Sunday afternoon. Indeed, from the smell of things at the ballpark, it may be more American than Mom and fast-food apple turnovers. Like all healthy establishments, the debate has certain

mechanisms which provide energy for its continued existence.

The phenomenon was institutionalized in 1937 when the Federal Government passed the Marihuana Tax Act. Since then, anti-cannabis interests have legislated into existence laws which strictly control access to cannabis on local, regional, and national levels. The Crown Jewel of this anti-cannabis legislation is a treaty among nations. It is called the United Nations Single Convention Treaty on Narcotics (1961).

In this agreement, cannabis is defined as a narcotic. This definition places cannabis in the same category as opium and its derivatives—heroin and morphine—and cocaine, hallucinogens, barbituates, amphetamines and tranquilizers.

The significance of the Single Convention Treaty, with respect to the use of cannabis in the United States, is that it takes the issue of legal classification of cannabis away from the citizens. In this treaty, two legal barriers prevent citizens from altering the basic nature of cannabis legislation: First, because of the treaty among nations, reclassification of cannabis would require the agreement of all 108 signatory nations. Second, according to the laws of the land (Supreme Court: Missouri vs. Holland, 1920), treaties with foreign nations take precedence over domestic legislation. Nullifying a treaty requires the sanction of the United States Supreme Court. In effect, the substance cannabis is an illicit narcotic and will remain so for many years to come.

In opposition to this legislation is the genetic diversity of cannabis-the-plant. This diversity enables the plant to grow weed-like in a broad spectrum of latitudes and attitudes. In addition, this diversity enables the plant to yield a number of products which, throughout recorded history, have satisfied a number of human needs. In fact, every part of the plant yields a product beneficial to the human race. The root system yields medicinal herbs; the stem yields hemp fiber; the flowers yield intoxicants and herbs; and the seeds yield animal feed, cooking oil, industrial lubricants and fuel.

By way of illustration, consider the product of hemp fiber. This fiber has provided the basic substance from which clothes, rope, paper, and canvas have been produced. In an interview published in *Esquire* magazine, Harry Anslinger said:

> Now this hemp is the finest fiber known to mankind; my God, if you ever had a shirt made of it, your grandchildren will never wear it out. We used to see marijuana in the yards of Polish families. We'd go in and start to tear it out and the old man came out with his shotgun, yelling, "These are my clothes for next winter."

While cannabis is usually associated with poor, lower-class families ("Polish"), such was not always the case. When the United States was young, cannabis provided one of the country's principal cash crops. Consider the thoughts of our founding father George Washington, who said in his *Writings:* "Make the most of the India Hemp seed and sow it everywhere . . . ."

In his *Garden Book*, Thomas Jefferson made this recommendation: "An acre of the best ground for hemp is to be selected, & sown in hemp & to be kept for a permanent hemp patch."

In an era of carefully manipulated resources—and severe shortages—the potential of any resource will not be denied. In the future, society may need to fall back on resources which were used in building this country so many years ago. Cannabis is one such resource. Consider the logistics of producing paper. In a 1916 work entitled *Hemp Hurds as Paper Making Material*, Dewey Lyster stated: "Every tract of 10,000 acres which is devoted to hemp raising year by year is equivalent to a sustained pulp producing capacity of 40,500 acres of average pulp-wood lands."

Today cannabis is used (unofficially) as a medicinal herb. It has proved itself effective in relieving the nausea associated with chemotherapy, reducing pressure in the eye from glaucoma, easing the spasticity of multiple sclerosis, relieving menstrual cramps, and any number of other ailments. The most popular use of cannabis, however, is as an antidote to the acids of Modern Times—an intoxicant.

While technology has enabled society to provide synthetic substitutes for many plant and animal products, these substitutes often benefit the patent holder more than they do the patient. The patient, however, recognizes what works and what does not work, and consumes on that basis. As long as cannabis proves effective for the consumer, there will be producers to provide the substance. That is true, at least, for as long as the law of supply and demand remains in effect.

This confrontation of values is fueled by the way people think. One segment of the population is adamantly opposed to cannabis and perceives it as a threat. Another segment considers cannabis to be high in substance value, and perceives it as a blessing. The extent to which these perspectives are shared and perpetuated assures the continued existence of this American institution.

Because of this environment, *The Sinsemilla Technique* is focused on a method of cultivating plants in adverse conditions. By its nature, the process of successfully cultivating plants must transcend the madness of conflicting perspectives. It is a reasonable endeavor in itself, governed by natural forces and limits. Says Knut Hamsun, in *Growth of the Soil*:

> Nothing growing there? All things growing there; men and beasts
> and fruit of the soil. Isak sowing his corn. The evening sunlight

falls on the corn that flashes out in an arc from his hand, and falls like a dropping of gold to the ground. Here comes Sivert to the harrowing; after that the roller, and after that the harrow again. Forest and field look on. All is majesty and power—a sequence and purpose of things.

There are, of course, considerable differences in cultivating corn and cannabis. Yet, at the core of each endeavor, is a relationship between person and plant. It is thought that by focusing on this relationship, a reasonable insight might emerge, one that would yield information of value to consumer and producer alike.

To me, the cultivation cycle is like a life preserver in a troubled sea. After years of research, I still do not understand the tremendous antipathy directed at this species of plant, nor do I understand the extent of the attraction for it. Indeed, much of the phenomenon of cannabis is beyond my ability to discern.

This lack of knowledge did not result from poor preparation. There have been times—many times—when I have found myself, like Ishmael, floundering in the sea as the Pequod goes down in the aftermath of Ahab's madness. For that reason, I leave the confrontations of values to the Ahabs of the world, and focus myself, instead, on this method of producing more substance value with less resources—this sinsemilla technique.

# Part One

# Stress

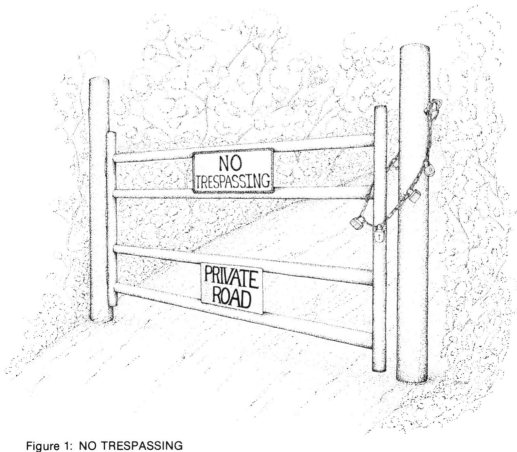

Figure 1: NO TRESPASSING

# Stress

*stress* /*vt -ed*/ -*ing*/ -*es* *1. archaic   a: to subject to hardship,
affliction, or oppression   b: distress   2: to subject to phonetic
stress: accent   3: to subject to physical stress   4: to lay stress
on: place emphasis on: make emphatic: emphasize*

--Webster's Third International Dictionary

A plant is subjected to adverse conditions. These conditions produce "stress."
To survive, the plant must summon the necessary will to contend and overcome.
This struggle, it is thought, develops the plant's character. In the ancient lore of
cannabis cultivation, the application of stress is the basis for a technique used to
increase the percentage of THC in an individual plant.

I was introduced to this technique by an apartment-dwelling cultivator in
Missoula, Montana. When the interview came around to methods of increasing
a plant's potency, he said: "There is only one way to increase potency. You have
to stress the plant." When I asked how one stressed a plant, he walked over to
the closet and selected one of the potted plants from beneath the lights, opened a
nearby window, then let the plant fall two stories into the snow below. "That's
how you stress a plant," he said.

Although it left me somewhat skeptical, I did not forget this demonstration;
and in the course of my travels, I discovered other manifestations of this ancient

practice: I saw plants with stakes driven through the stem, plants pulled over into strained arcs and secured to the ground, and plants deprived of water. Indeed, all seedless cannabis is produced by stifling the female plant's reproductive cycle—one of the more intense forms of stress. One cultivator, a member of a cannabis-related religious sect, emphasized: "You can do anything to the marijuana plant, but please don't fertilize it."

When asked how stress improves the potency of a plant, cultivators respond by saying that while stress inhibits the metabolic factors of growth—photosynthesis and respiration—it may not inhibit the synthesis of cannabinoids. In other words, stress acts to concentrate the cannabinoids within the plant.

Authorities on the subject—those who have published works on cultivation—tend to agree in principle with the theory. They emphasize, however, that stress also diminishes the total yield of plant matter. Says Michael Starks, in *Marijuana Potency* (And/Or Press): "The consequences of these observations for the marijuana farmer are clear. You have two basic choices: high potency and low yield or lower potency and high yield." For that reason, stress is usually dismissed as being unreasonable. This is, after all, a hungry world.

But through that demonstration in the snow of Missoula, Montana, I developed a fascination with the concept that would not go away. In fact, I began to look upon every secret garden as a manifestation of that ancient practice of stress. While few cultivators actually torture their plants for the last drop of THC, every cultivator and every plant is forced to struggle against a broader, more profound kind of stress—institutionalized Prohibition.

Prohibition was instituted to eliminate cannabis from the earth by classifying the plant as an illicit substance. Like falling two stories into the snow, this classification is a form of adversity. This adversity, however, has not proved adequate to the task of eliminating cannabis. On the contrary, it has served to validate the ancient practice of stress by making the plant more than it would be were it left to grow wild and free like the weed it once was.

Prohibition accomplished this feat by carefully nurturing the supply and demand of the market. By focusing the attention of the public on this plant for the last eighty years, Prohibition has alerted people to the fact that cannabis is a very special plant. In doing so, ironically, it has stimulated demand. Prohibition also acts to supress the supply of cannabis through the systematic eradication of gardens. This elimination of supply, quite naturally, raises prices to the point where the incentive to produce cannabis becomes incredibly strong.

Today, the stress of institutionalized Prohibition is the common denominator in every cannabis equation. In cultivation, it affects everything from the selection of seeds to the harvest. The sinsemilla technique evolved in response to this adversity. For this reason, I have chosen to emphasize the effects of stress by placing the subject here, at the beginning of the *The Sinsemilla Technique*.

# Effects of Stress on Demand

No substance has value unless there is a demand for it. To create demand for their product, companies resort to advertising, which emphasizes a product's virtues through repetition. As seen in Webster, this emphasis is a form of stress (4. to lay stress on: place emphasis on: make emphatic: emphasize). If the advertising is repeated enough, people will begin to see the need for the product.

Prohibition has employed advertising in an effort to rid the world of cannabis. Since the turn of the century, citizens have been warned of the dire consequences of consuming cannabis. Through newspapers, radio, and television, Prohibition's forcefulness of expression has repeated the warning millions of times. The result of this stress is that millions of people know about the substance cannabis and appreciate its virtues.

To understand how this stress has influenced the cultivation of cannabis, some perspective would be useful. Toward that end, I will use some before and after snapshots. Through these word-pictures, one can follow the progression of

Figure 2: CORDON

demand for cannabis. From its position in the pre-Prohibition markets until today, there have been some remarkable developments in the demand for this green plant.

Cannabis has always been a part of the American landscape. One finds it woven through history much like the fiber rugs upon which our ancestors used to walk. In 1619, for example, the Virginia General Assembly made it mandatory for those citizens who possessed Indian hemp seeds to plant them. And the hardy pioneers planted. In *The Reign of Law: A Tale of the Kentucky Hemp Fields* (published in 1900), James Allen described this industry:

> The roads of Kentucky, those long limestone turnpikes connecting the towns and villages with the farms—they were early made necessary by the hauling of the hemp. For the sake of it slaves were perpetually being trained, hired, bartered; lands perpetually rented and sold; fortunes made or lost. The advancing price of farms, the westward movement of poor families and consequent dispersion of the Kentuckians over cheaper territory, whither they carried the same passion for the cultivation of the same plant—thus making Missouri the second hemp-producing state in the Union—the regulation of the hours in the Kentucky cabin, in the house, at the rope-walk, in the factory—what phase of life went unaffected by the pursuit and fascination of it. Thought, care, hope of the farmer oftentimes throughout the entire year! Upon it depending, it may be, the college of his son, the accomplishments of his daughter, the luxuries of his wife, the house he would build, the stock he could own—all these depending in large measure upon his hemp, that thickest gold-dust of his golden acres.

While Mr. Allen's observations are somewhat colorful, according to the custom in his day, we may still see that the plant cannabis was but another crop in the nation's breadbasket. And such was the case until shortly after Mr. Allen's book was published; then things began to change.

In the waning years of the 1800's, the United States realized that it had a substance-abuse problem. According to surveys as much as 1% (250,000) of the population was addicted to opium, morphine, heroin, and cocaine. The majority of this addict population consisted of white middle-class females across the land. This problem of substance-abuse was the result of over medication and careless prescription practices—a case of "Do what the doctor tells you to do."

Harry Anslinger illustrated the plight of the typical addict in *The Murderers—The Shocking Story of the Narcotic Gangs*:

As a youngster of twelve, visiting in the house of a neighboring farmer, I heard the screaming of a woman on the second floor. I had never heard such cries of pain before. The woman, I learned later, was addicted, like many other women of that period, to morphine, a drug whose dangers most medical authorities did not yet recognize.

Society reacted to this problem of substance-abuse in a most civilized manner. All concerned gathered together and, through self-regulation, prescription labeling laws and education, controlled the epidemic of addicted housewives.

At the turn of the century, however, another outbreak of narcotics abuse was discovered. This problem had a new dimension. In the large metropolitan areas of the country, people were discovered consuming these substances for "pleasure." Unlike the earlier addicts, these pleasure-seekers were not members of the middle class, but dwellers on the other side of the tracks, and predominantly of a different color or occupation.

To combat this problem of substance-abuse, war was declared. Citizens banded together and passed ad hoc legislation aimed at eliminating the abused substances. These ad hoc laws culminated when the Federal Government passed the Harrison Narcotics Act, of 1914. All was then safe, for a while.

In the decade after the Harrison Act was passed it was discovered that a new substance was being enjoyed. Cannabis was being smoked by those people living on the other side of the tracks.

In fact, there is much evidence to suggest that cannabis had been used as an intoxicant from the beginning. While the cannabis of the day was cultivated for its fiber, and was of the low-THC variety, the plantation worker on the large Kentucky hemp plantations must have found it hard to resist the sweet, rich aroma emanating from the flowering tops of the hemp plant. Said James Allen, in *The Reign of Law*:

> ...the odor of those plumes and stalks and blossoms from which is exuding freely the narcotic resin of the great nettle. The nostrile expands quickly, the lungs swell out deeply to draw it in: fragrance once known in childhood, ever in the memory afterward....

It was, after all, the practice back in Africa, and the Middle East, and Far East. This use of cannabis for "pleasure" was illustrated to me by an old

6

campaigner I met in Los Angeles. When our conversation drifted into cannabis, he smiled and said: "Goof Butt. That's what we used to call them in the cavalry—Goof Butts. After duty, we would go out behind the corral and goof-off."

Because this problem was centered in the minority population, it was treated with the same ad hoc warfare as had been the earlier outbreak of pleasure seeking. There were no scientific studies to classify the properties of cannabis; it was assumed to be a narcotic, used by the less desirable elements of society for pleasure. A public relations campaign was launched against cannabis, culminating in the Federal Marijuana Tax Act of 1937 and subsequent legislation.

With Prohibition, cannabis received a tremendous amount of exposure in the nation's press. In fact, the nation was just recovering from the "Great Experiment," and forcefulness of expression was the order of the day. In a syndicated story, Universal News Service writer Kenneth Clark wrote in 1936:

> Shocking crimes of violence are increasing. Murders, slaughterings, cruel mutilations, maimings, done in cold blood, as if some hideous monster was amok in the land.
>
> Alarmed Federal and State authorities attribute much of this violence to the "killer drug."
>
> That's what experts call marijuana. It is another name for hashish. It's a derivative of Indian hemp, a roadside weed in almost every state in the Union....
>
> Those addicted to marijuana, after an early feeling of exhilaration, soon lose all restraints, all inhibitions. They become bestial demoniacs, filled with the mad lust to kill....

Today, cannabis still makes headlines in the nation's media. One can see the effect of this emphasis on the demand for cannabis in current coverage of the phenomenon. In a recent article for the *San Francisco Chronicle* Herb Caen illustrates the effects this stress has had on the "roadside weed" of yesteryear.

> Yankee Know-How is still alive, or, you too can be a sinse-millionaire: The biggest crop in Mendocino County is marijuana, officially or otherwise. Mainly otherwise. And the marijuana is mainly sinsemilla, which, says a narcotics officer admiringly, "is a production technique, like fine winemaking." At $1500 to $3000 a pound wholesale, VERY fine, with a high to match....

I have included these observations not for the accuracy of their statements, but to illustrate the forcefulness of their expression. With so much stress, cannabis became known throughout the land as a very special plant. Today the "roadside weed" has been eliminated from almost every state in the Union; in its place grows the potent cousin sinsemilla—cultivated in the utmost of secrecy in every state of the Union. While one cannot point to any one reason for this escalation in demand, one cannot help but wonder at the effects of some eighty years of high voltage hyperbole.

# Effects of Stress on Supply

While Prohibition continues to stress the adverse characteristics of cannabis, it also applies another kind of stress to the substance. This is the stress of a force being exerted upon something. (Webster's Third:   1. archaic   a: to subject to hardship, affliction, or oppression   b: distress.) Unlike the stress of emphasis, however, this force has physical manifestations which can be observed and felt. This force is directed at the elimination of cannabis through the systematic elimination of secret gardens.

The most familiar manifestation of this stress is the bust. Aerial surveillance, paid informants, and gossip funnel information to various levels of government. This information is then passed along to the local Marijuana Eradication Teams. In the autumn of the year, when the plants are nearing harvest, this local effort applies a lot of adversity.

In some respects, this situation is similar to that of the elderly couple who live down the street. Since they are retired and of comfortable means, they dedicate a significant portion of their day to the upkeep of their well-manicured yard. Unfortunately, other residents of the neighborhood do not have the time, or inclination, to be so scrupulous in attending to their yards, and consequently harbor many varieties of weeds. When these unwanted plants appear in the couple's yard, war is declared and chemical weed retardants sprayed from fence to shining fence.

In the context of this elderly couple and their yard, stress is the force of poison applied to the growth of unwanted plants. In the context of society and Prohibition, stress is the force of the bust applied to the secret gardens. This adversity diminshes the supply of cannabis.

Figure 3: BONSAI

The enforcement of Prohibition works to diminish the supply in other, more subtle ways. It restricts cultivation to the most marginal of agricultural environments and creates an adverse social climate for the cultivator.

In every environment there are certain forces which create adversity for growing plants. Insects, pests, inclement weather, and soil erosion are causes of stress which occur in nature. By restricting cultivation to marginal environments, Prohibition acts to multiply the effect of these natural causes of stress.

In addition, cultivators are forced to use seed strains which lack the vital genetic intelligence needed to cope with these adversities. Within every seed is intelligence which will enable the living plant to survive a particular environment and yield a particular product. This intelligence (genotype) evolved through generations of adapting to a specific climate and purpose. This intel-

9

ligence recognizes adverse conditions in the native environment and makes compensations for them in the living plant. For example, seeds from Afghanistan are keyed to growth in the high, dry environments of the desert. Afghani plants, therefore, are genetically prepared for drought conditions. For this reason, the genotype is a primary consideration when seeds are selected for germination.

Cannabis seeds are divided into two groups, *Cannabis sativa* and *Cannabis indica*. (There is also a category called *Cannabis ruderalis*, a short, wild variety not—at this time—in cultivation.) These categories evolved through climate and purpose. The native strain in North America is a varietal of *Cannabis sativa*. It evolved in response to the climate of Midwest farmlands for the purpose of yielding fiber.

Because of Prohibition, cannabis is no longer cultivated for fiber. Instead it is grown exclusively for its ability to yield cannabinoids. For that reason native seeds are rejected in favor of seeds from a more favorable genotype. These genotypes represent the purpose of other lands, where through ancient custom, cannabis is cultivated for the cannabinoids.

While these seeds represent a favorable genotype in terms of purpose, they lack intelligence of the American climate. When germinated, the seeds grow into an environment which is unfamiliar and therefore adverse. If, for example, one were to take a polar bear cub from its home on the ice of the far north and transport it to the hot sands of Death Valley, one would expect the cub to experience a good deal of adversity. Though this simile may seem a bit overdone, the equivalent is accomplished almost routinely by cultivators around the United States.

I was given a demonstration of the reaction of seeds to this adversity while in the Puget Sound area one cold, rainy night in January. My guide, a civil servant employed with a local government, introduced me to the native environment by driving through the rain-forest to his suburban home. As we walked around the house toward a decrepit looking shack out back, the frozen lawn cracked beneath our feet. Once inside the shack, I was greeted by a stand of Afghani plants transpiring under 1000 watt metal halide lamps.

That these plants were alive at all was a tribute to the ability of the plant, and cultivator, to adapt. But that they were growing in a shack at sea level in the Puget Sound area was a tribute to the forces of Prohibition. From the looks of the plants, the cultivator would reap a harvest in a few weeks. But, because of the adversity of the environment, the size of this harvest would be miniscule compared to that of an ordinary plantation in Afghanistan.

By applying the force of legal sanctions against cannabis, Prohibition creates an adverse social climate for cultivation. Of all the forms of stress directed at cannabis, legal sanctions affect the cultivator most directly. In the secret garden, forces which affect the cultivator also affect the plants. By applying force, Prohibition attempts to create enough social adversity to eliminate cannabis by

discouraging people from becoming cultivators.

By way of illustration, consider the young couple who live up the street. Unlike the retirees mentioned earlier, this young couple have taken a liking to weeds. Indeed they speak wistfully of how easy it would be to grow 500 cannabis weeds in the vacant lot next door. But they are a respectable couple who value their position in the neighborhood, and for that reason leave the vacant lot in fallow.

While sanctions provide enough adversity to keep this lot vacant, they are not strong enough to stifle the couple's fascination with cannabis. As a result they cultivate three potted plants in the privacy of their backyard. Although these three plants yield enough cannabis for the couple and their friends, the yield is small compared to the possibilities inherent in the vacant lot.

This is not to say that Delegated Authority actually goes into every secret garden and pulls plants up by the roots. Indeed, it prosecutes only a small minority in this fashion. However, Prohibition creates an emotionally charged environment which permeates every garden to one extent or another. Many cultivators fail to adapt to this adversity and consequently the cultivation cycle is interrupted by chaos.

I visited one garden in which the plants displayed this chaos in the tips of their leaves. The garden was hidden on a five-acre parcel of the Coastal Range close to the metropolitan San Francisco Bay. Because there were so many people around, the garden was small and hidden deep in the underbrush. To get a good yield from these few plants, the cultivator fertilized them often. As harvest neared the pressure increased. He became anxious and forgot to read the directions on a new jug of fertilizer. The resulting overdose burned the plants and they began dying from the tips of the leaves inward.

Often chaos becomes manifest in the cultivator, with negative results for plant and person alike. By way of illustration, I quote from an article in the *Santa Cruz Sentinel*:

### Man Fires Rifle Shots Toward Deliveryman

A 24-year-old man was arrested Monday after he fired a rifle at a deliveryman who came to his home for assistance, sheriff's deputies reported today.

According to reports, a 19-year old San Jose man was delivering a load of blocks to a construction site near B's home when he discovered an exit gate had been locked during the time he was making the drop-off.

The man went to B's residence to ask for the combination to the gate lock, but the resident refused to give it to him.

The victim said he became angry and berated B.

11

B went into his house and got a rifle. According to reports, B said he fired into the air several times to scare the victim.

The victim said he dropped to the ground when he heard the shots, then ran to his truck and fled when they stopped.

Santa Cruz deputies were called to the scene a short time later and arrested B, who was standing outside his home with a rifle in his arms, according to reports.

He told deputies he only wanted to scare the victim and had looked for him later to apologize.

Deputies also found a greenhouse with 9 marijuana plants and a plot of 13 additional plants near the house.

By failing to adapt to his stress-filled environment, B no longer tends his plants. In B's garden, the stress of Prohibition was successful in eliminating production. While B's overdose may be a bit extraordinary, stress often plays an important role in the timing of a cultivation cycle. Indeed, the criteria for selecting the time of harvest are, more often than not, determined by when the cultivator simply cannot cope with the stress anymore.

# Effects of Stress on Character

Notwithstanding these stress-filled environments, the consumer demand for cannabis is profound. According to the law of supply and demand, when a substance is in high demand and short supply, the price will be high. High prices create incentives to produce. Yet cultivators of cannabis can produce only so much before the stress of Prohibition overwhelms the production scheme. Cultivators, therefore, make up in quality for what they are unable to produce in quantity.

Techniques which improve the character of cannabis are important to the cultivator for that reason. Many cultivators are generations removed from the ways of the soil; consequently, any suggestion to improve the character of their plants is considered. Tales of ancient practices of stress—water deprivation, stem-splitting, etc.—fall on eager ears. The resulting irony is that one finds cultivators in already stress-filled environments torturing plants to improve quality.

12

While this redundancy may seem a bit strange, it does serve to illustrate the importance of the quality. To understand what this quality is, let's look into some legal gardens. Plants are cultivated for many reasons. Some plants are cultivated for food or fiber. These plants provide us with the necessities of life; consequently, the quantity of production is very important.

But we cultivate plants for reasons other than basic survival. We cultivate plants for aesthetic reasons, like the rose; or for even more personal reasons, like the grape. Since these plants do not fulfill any of our basic needs, production levels are not of critical importance. We value these plants for the quality of their character. The rose, for example, stimulates our sense of smell and sight. If the rose can be induced to yield more color and fragrance, it will increase the stimulation of our senses and consequently have more character. In the market place, the rose will have more value.

Figure 4: ESPALIER

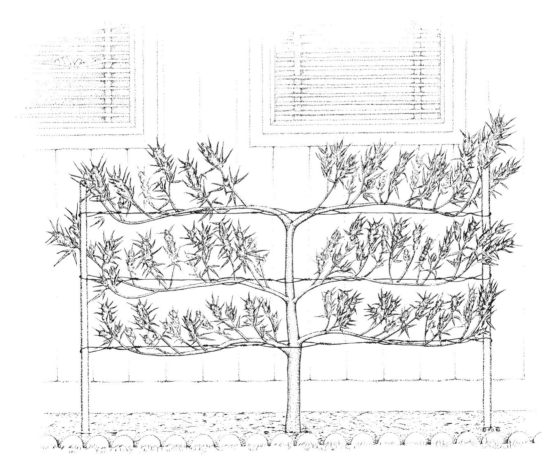

If we were to attend a seminar on improving the character of those plants which please our senses, we would hear the merits of the ancient practice of stress being discussed as if it were a religious doctrine.

The grape is a good example of the value of character. Connoisseurs of wine consider character to be extremely important in determining the value of wine. Color, bouquet, taste and alcohol are aspects of this character. To improve this character, wine makers talk of obtaining grapes from stressed environments. Consider the testimony of these experts, as quoted from *Great Winemakers of California* (Capra Press):

> We prefer to get grapes from low production vineyards. We strive for that because it seems in practice that when you are making wines from grapes that have been grown with low tonnage per acre, you get an intensity of flavor and aroma you do not get from grapes produced in two or three or four times the volume, from a rich, fertile, valley location.
>
> Paul Draper, Ridge Vineyards

> Vines are like humans, and when they have to struggle for themselves from the day they're born and they manage to survive in that rock, they produce a beautiful grape.
>
> James Concannon, Concannon Vineyards

> A lot of the flavor and color components of the grapes are associated with skin tissue and cellular structure immediately under the skin, so it stands to reason that if you crush a lot of properly ripened small berries from hillside vineyards you get a heavier and more flavorful wine than if you crush fewer of the larger berries from valley floor vineyards.
>
> Brother Timothy, The Christian Brothers

These master winemakers are concerned with the quality of the grape. To compete in the marketplace with large corporations, they must produce wine of exceptional character. Consumers value this character and are willing to pay a little more than they would for a jug of "Real Red" from the steel tanks of the XYZ Corporation. Since volume is not of absolute importance, winemasters are consumed with identifying growth factors which improve the quality of the grape. From the testimony of these experts, we see that a stressed growing environment is one of these factors.

Consumers of cannabis also have a concept of character quality. As with wine, taste, bouquet, and appearance are aspects of this character. Unlike the

alcohol in wine, the THC in cannabis is illegal; consequently, cultivators have no choice in the selection of growing environments. Prohibition-imposed restrictions force cultivators to use remote ridgetops, steep slopes, and damp basements. There are no plantataions of cannabis in the rich, fertile soil of the valley floor.

The Drug Enforcement Administration (DEA) studied the potency levels of various kinds of cannabis in their laboratories in Washington, D.C.. In this study the DEA found that THC levels in "normal" cannabis—that which grows wild or is imported from other countries—ranges from 0% to 2.5%. Domestic cannabis—that which is cultivated in the stress-filled environments of the United States—ranges from 2.8% to 7.96%. Since the domestic varieties were cultivated from seeds from "normal" cannabis, it must be assumed that the stress of Prohibition has indeed improved the character of cannabis.

Contending with this stress-filled environment is the common denominator in every cultivation equation. Prohibition forces the cultivators to grow fewer plants in smaller places. To adapt, the cultivator must find ways of producing more substance value with fewer plants. This fact creates a parallel to the ancient cultivation practice: If you want to improve the character of a cultivator, you must apply stress.

While there may be exceptions, cultivators of cannabis do not become "sinsemillionaires." In filming a documentary on sinsemilla cultivators in 1980, I visited 23 gardens throughout the West. Since this project consisted of filming the process from beginning to end, I came to know the cultivators quite well. Although all but two of these gardens yielded a successful harvest, not one of these people became rich through his/her labor. Cultivation is a labor-intensive occupation and one does not become rich on one's own labor.

There was, however, another kind of wealth apparent in the lives of these cultivators—the wealth of being independent. By successfully producing a much sought-after product in marginal environments and under stress-filled conditions, these cultivators earned a degree of independence rarely found in our centralized society. Indeed, they lived in a countryside long-since mined of natural resources, bartered with their neighbors for services, built their own roads, and perhaps even bought a new vehicle to get through the rainy season.

In an interview published in the *San Francisco Chronicle/Examiner,* a Mendocino solar entrepreneur described the wealth of this independence: "People around here want to be out of the mainline. They don't want to be hooked up to the energy grid. The money from marijuana has enabled them to do this. This is one of the few places where people are making electricity without the megabucks of government money. Around here, we have more of a living application of solar technology—rather than the typical showroom demonstration project."

The effects of stress upon cultivation have been noted before. My favorite

example has always been the rooftop gardens of World War II London. In hot-house environments cultivators grew bananas while high explosives rained from Nazi bombers. Imagine the taste of that fresh fruit midst all those ashes!

To conclude, I would like to return to the cultivator who introduced me to the ancient practice in the snow of Missoula, Montana. In an apartment closet, he grew cannabis with more character than any "normal" cannabis he could buy on the streets. Were there no Prohibition, this person might have cultivated his cannabis in the garden with the rest of the plants. Given the prolific nature of the plant, he might have harvested something familiar—like zucchini in August. Through his struggle to grow in adversity, he learned how to produce more substance value in less space. For this reason, he is a perfect example of how stress improves character.

# Part Two

# The Sinsemilla Technique

# The Sinsemilla Technique

The sinsemilla technique is an evolutionary development in one of mankind's oldest occupations—the cultivation of plants. As with all forms of agriculture, the sinsemilla technique is a method of providing a plant with its requirements for growth.

The revolution in agriculture occurred back in the dawn of human consciousness. Tired of wandering the land in search of food, some hungry soul stumbled upon the ability to domesticate wild plants and live from the fruit of this ingenuity. This development freed the tribe from its constant wandering, enabling it to stay in one location and build culture. In this sense, the domestication of plants was the foundation upon which society was built.

Since then, mankind has sought ways to improve the ability to husband plants. Through this quest for a better living, some remarkable wonders have been achieved. In the United States, for example, chemicals, machinery, and processing are elements of contemporary agricultural techniques. These techniques have significantly altered the work-load of the American citizen. At the turn of the century, 45% of the population was employed in the production of food and fiber. Today, with a greatly expanded population base, only 3% to 4% of the population earn sustenance by cultivating plants.

In the near future, technological advances may increase the efficiency of these techniques even more. Genetic engineering, for example, may enable one to graft the genes of a food-producing plant—like the sweet corn—with that of a nitrogen-fixing plant—like the fava bean—to yield a self-fertilizing plant capable of growth in the most desolate of soils.

Because of their influence on society, these developments in technique are often called revolutionary (i.e. "The Green Revolution"); but their importance notwithstanding, these developments are evolutionary in nature. Where our

forebears used a shovel and hoe, we use diesel tractors. Where our forebears relied on rain, we harness giant rivers. While profound, these developments are merely advances in the same old occupation—encouraging the growth and productivity of plants.

Agricultural techniques address a fundamental problem in production: How can plants be induced to yield more substance value (food and fiber) in an environment of diminishing resources. In the cultivation of cannabis, the problem is especially acute. Cannabis requires certain elements from the environment for growth. These elements are air, light, temperature, water, soil and minerals. In this respect, the plant is no different than sweet corn. In other respects, however, cannabis is unique among plants. As a component of its chemistry, cannabis contains Delta 9—Tetrahydrocannabinol (THC). This chemical is an unusual and illicit substance.

Because it is illegal, cannabis is not cultivated in the prime agricultural environments of open fields. To provide the elements necessary for growth, and to avoid the effects of Prohibition, cultivators locate their plants in small garden plots with marginal environments. These environments strictly limit the number of plants which can be cultivated. This limitation can be extrapolated into the basic production problem of horticulture: How can more substance value be produced with fewer plants in smaller gardens?

The sinsemilla technique works in two ways to increase production. First, it encourages each plant to reach its maximum potential growth rate. Second, it improves those aspects of each plant which, from the consumer's standpoint, constitute character. Through this technique, a small garden plot can become the functional equivalent of a large one.

In this manner, the sinsemilla technique resolves the fundamental production problem. Yet, while most contemporary agricultural techniques enable fewer people to cultivate more plants, the sinsemilla technique enables more people to cultivate fewer plants. In effect, it is a labor intensive technique, and therefore unique in Modern Times.

# Chapter 1

# The Transpiration Stream

Cannabis is an autotroph. As with other chlorophyl-bearing plants, cannabis takes simple inorganic elements and compounds from the environment and converts them into the more complex organic compounds of life. This conversion is carried out through the metabolic processes of photosynthesis and respiration. Because green plants have this ability, we classify them as being autotrophic, or "self-feeding."

Autotrophs are distinguished by comparing them to heterotrophs. Heterotrophic organisms require the outside nourishment of complex organic compounds to complete metabolic systhesis. People are a good example of heterotrophic organisms.

I mention this because people often claim to have grown plants: "I grew this sweet corn from seed." Autotrophs possess the intelligence to feed themselves; people do not grow them. Indeed, the converse is closer to the truth. However, the growth of autotrophs can be enhanced through improving their environment and by giving direction to their cycle of growth. In other words, people may cultivate plants to improve the rate of production.

Cultivation implies an intimate relationship between person and plant. Before an environment is improved, or direction given, the person must have a good understanding of the plant and its requirements for growth. This intimacy is often called the "green thumb." For example: "Hey, have you seen Lovely Linda's lentils? That lady has some kinda green thumb."

This rationalization, however, diminishes Linda's knowledge of plants by ascribing her ability to some kind of magical thumb. While Linda may not know the biological principles of autotrophic metabolism, her knowledge of plants

20

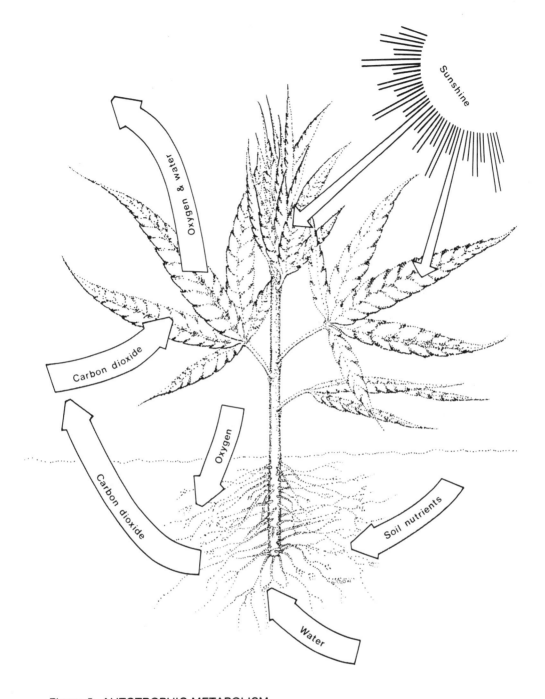

Figure 5: AUTOTROPHIC METABOLISM

enables her to increase the production rate of her lentils. This type of knowledge is the result of a person communicating with a plant via the flow of the transpiration stream.

The transpiration stream is the cyclical flow of water from atmosphere into soil, soil into plant, and from plant back into atmosphere. Through this flow, the

21

plant is provided with some of the elements necessary for metabolic synthesis. The principal activities of this metabolism—photosynthesis and respiration—occur at the cellular level, and are therefore not observable. The transpiration stream, on the other hand, can easily be monitored by an attentive person and, for that reason, is the best indication of the plant's rate of growth.

To illustrate how this flow of water can be used as a communication link with plants, I will sketch the metabolism of growth.

Respiration and photosynthesis are processes which occur simultaneously in the manufacturing of new plant tissue. Respiration is the process by which plants breathe in carbon dioxide and exhale oxygen. Photosynthesis is the process by which plants convert inorganic elements into organic carbohydrate compounds. The ingredients for this conversion consist of radiant energy (light), water, and carbon dioxide.

Simplified, metabolism works like this: Radiant energy from the sun is absorbed into microscopic bodies called chloroplasts, found inside individual plant cells. Within these chloroplasts is a substance called chlorophyl, which is capable of absorbing certain wavelengths of light radiation. This radiant energy is then converted into chemical energy via photosynthesis. This chemical energy is used to split water molecules ($H_2O$) and combine them with carbon dioxide ($CO_2$) to form carbohydrate compounds ($(CH_2O)n$) and oxygen ($O_2$).

In the process of converting radiant energy into chemical energy, the plant also incorporates into its protoplasm a variety of inorganic elements and compounds from the soil. Nitrogen, phosphorus, and potassium are primary requirements for new plant tissue. Minerals of secondary importance are calcium, magnesium, and sulfur. Also required in minor amounts (trace elements) are iron, boron, chlorine, manganese, copper, zinc, and molybdenum.

These nutrients are provided through the flow of the transpiration stream. As this flow is cyclical, it has no beginning or end. Nonetheless, we will begin following it in the soil. Organically rich soil is inhabited by various organisms we call decomposers. Some of these organisms are mere microscopic bacteria, and some are larger and more familiar, like the earthworm. Through their metabolic activity, these organisms convert organic matter into inorganic minerals.

These minerals become water soluble at a rate governed by, among other things, the soil pH. pH is the measurement of acidity or alkalinity present in a given substance. It is measured on a scale of 0 to 14, with acid being 0–6 and alkaline being 8–14. Distilled water is a neutral substance measuring 7 on the pH scale.

When water enters the soil from the atmosphere it forms an emulsion with these minerals. This solution is then absorbed into the root system of the plant and passed along to the rest of the plant via the xylem. The plant incorporates these soil nutrients into its protoplasm and, together with the carbohydrate compounds and oxygen, builds the more complex molecules like amino acids

22

and proteins through enzymatic synthesis.

The plant will use a small percentage (between 1% and 6%) of the flow of water in the conversion of energy and in the manufacturing of food. The balance of this flow is transpired (with the oxygen produced in photosynthesis) through stomata back into the atmosphere. The cycle of the transpiration stream is then complete.

Because the principal functions of metabolism occur at the cellular level, the cultivator is unable to visualize them. Indeed, one could sit all day without once seeing a plant photosynthesize. The transpiration stream, however, provides an observable link between a plant's metabolic functions and a cultivator. If the flow of water (and nutrients) is strong, metabolic activity must also be strong. If the flow is weak, metabolic activity must also be weak.

If the transpiration stream is monitored over a period of time, it becomes an interface between person and plant. Through this communication, a person can understand how things are going within the plant. Once this familiarity has been established, the person can begin to improve the environment in such a manner as to improve the plant's productivity.

In some respects, this situation could be compared to that of a high-performance automobile mechanic. To increase horsepower in an engine, the mechanic increases the availability of those elements needed for combustion: fuel, heat and oxygen. By adding carburetion, more efficient spark, and a turbocharger, then increasing the flow of exhaust, the mechanic is able to increase the engine's horsepower rating. To co-ordinate these elements so that the engine runs smoothly, the mechanic uses instruments and a sense of feel, developed through experience.

While there is not—at this time—a turbocharger for plants, cultivators perform the same function by manipulating those elements in the environment which affect metabolic activity. And while there are no instruments to coordinate these elements, the person must rely on the flow of the transpiration stream to provide an indication of metabolic activity.

In the cultivation of cannabis, this familiarity with plants can result in a genuine green thumb. After a session of "communicating," the cultivator might find a layer of sticky green resin coating the fingers and thumb. The cultivator might rub it off, stick it into a pipe, and say something like: "WOW!! This green stuff on my thumb is some kind of magic!"

# Chapter 2

# The Cultivator's Dilemma

Plants are cultivated because they provide sustenance for mankind. This sustenance comes in many forms. Farmer Jones, for example, has forty acres of corn under cultivation because the plants yield food high in nutrition. A neighborhood association, on the other hand, has forty poplar trees under cultivation, because the trees screen the neighborhood from an obnoxious freeway system.

Because plants provide these forms of sustenance, people take the time to provide them with the elements necessary to sustain their growth. This relationship is symbiotic because it provides both people and plants with a means of support.

Cannabis is one of many plant species under cultivation. As with other chlorophyl-bearing plants, cannabis requires certain elements from the environment to complete metabolic synthesis. In this respect, the cultivation of cannabis is no different than the cultivation of sweet corn, poplar trees, or even watermelon.

Yet cannabis contains a certain class of chemicals, called cannabinoids, found in no other plant species. These cannabinoids are somewhat of an enigma in that they do not affect the plant's metabolism or reproduction, nor do they protect the plant from adversities in the environment. Cannabinoids are just there—a gift from mother nature.

There are several dozen of these cannabinoids present in the cannabis plant. They are a function of the plant's genotype, or genetic ancestry. The highest concentration of these chemicals is found in the resin bracts of the female cannabis flower. Of these chemicals, one in particular—Delta 9-Tetrahydro-

Figure 6:
Members of a local
Marijuana Eradication
Team on their way to
the harvest.

cannabinol, or THC—is significant, because it produces an unusual effect when consumed.

This unusual effect is the subject of considerable contention. A major segment of the population considers it in the negative sense, and has therefore restricted the use of cannabis through legislation. A significant minority, however, considers it a form of sustenance, and therefore has placed demands upon the market for cannabis products.

In the cultivation of cannabis, this contention creates a logistical problem one could call "the cultivator's dilemma." As with all dilemmas, this one is a problem seemingly without a solution. It is the factor which makes the cultivation of

25

cannabis different from any horticultural endeavor previously attempted by mankind.

To understand how this dilemma affects cultivation, let's examine the needs of the growing cannabis plant.

As mentioned previously, cannabinoids are a function of genotype. To produce THC, the cultivator merely selects seeds with the genetic potential to yield high percentages of THC. The rest is up to the plant and the ability of the cultivator to increase the productivity of that plant.

A plant's rate of growth is determined through its metabolic biosynthesis. Environmental factors which affect biosynthesis are light, temperature, water, soil, and nutrients. When all of these elements are present within the environ-

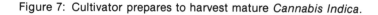

Figure 7: Cultivator prepares to harvest mature *Cannabis Indica*.

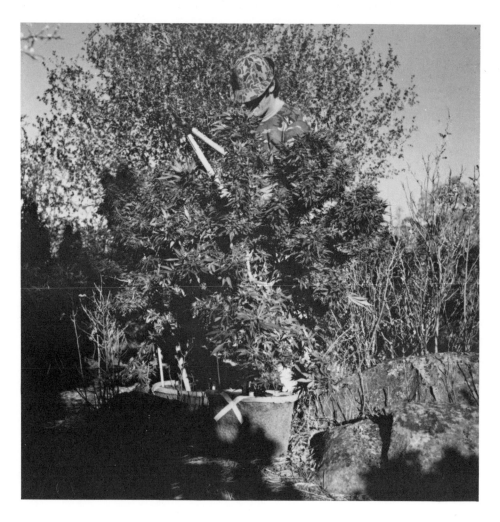

26

ment of a garden, and are in sufficient and available supply, the maximum rate of biosynthesis can be realized. If one of these elements is missing, or is not sufficiently available, metabolic activity will be restricted. The plant, in turn, will be subject to overstress, resulting in disease or death.

The plant's needs, therefore, are centered on the systematic organization of environmental elements within the confines of a garden. Yet because cannabis is prohibited, the plant also needs a smooth and orderly season of seclusion.

By restricting the growth of cannabis, Prohibition increases its value. As a result, many special interest groups look upon this plant as a valuable commodity. Consumers value the plant for the unusual effect it produces. Police value the plant because it is one crime that is cost effective to detect and prosecute. Politicians value the plant as an easy way of harvesting votes. Thieves value the plant as a cheap way of making easy money.

One sinsemilla cultivator described this value by saying, "It's like having $100 bills hanging from the branches of a tree." Because of this value, the cannabis plant needs an orderly season of seclusion. Without it, the plant is likely to suffer the fate of General Custer and his men at the battle of the Little Big Horn.

These requirements escalate with the advance of the cultivation cycle. When the plant is small it can process only so much sunshine, temperature, water, soil and nutrients. As it grows, however, the additional plant mass increases its rate of metabolic activity. As a result, the elements which were sufficient at the beginning of the cultivation cycle will be insufficient toward the end.

When the plants are small seedlings, they are easily concealed in small, out-of-the-way locations. But in the autumn, when surrounding native vegetation is struggling against the coming winter, the well-tended cannabis plant can be seen from thirty miles away . . . at night . . . in a storm, or so it is said.

The cannabis plant needs an ample supply of environmental elements and an orderly season of seclusion. These needs are mutually exclusive. Where one finds the sunshine to bathe in the nude, one finds many nude sunbathers. Such is the nature of the cultivator's dilemma.

Every secret garden is a manifestation of somebody's confrontation with this dilemma. Since each garden is unique, the resolution of this dilemma is determined through the exigencies of each garden. While some cultivators are able to successfully confront this dilemma, others are not. For example, consider this news item culled from a small town newspaper in California:

### Garden Hose Leads
### Cops to Pot Field

Two men were arrested on marijuana cultivation charges Saturday after deputies followed a watering hose to an illegal marijuana field and two suspects.

D.W., and R.B. were booked in County Jail on suspicion of cultivation of marijuana following the discovery of the field.

Officers found approximately 50 to 100 plants at the site.

According to reports today, the officers were driving back down a dirt road near N. Creek Road when they spotted a car with its doors open and a garden hose that hadn't been there before.

The officers followed the garden hose through dense brush to the marijuana field.

There, they found W. watering the plants and B. leaning against a tree drinking beer, said reports.

The two were taken into custody.

Often fate plays an important role in determining the outcome of a cultivator's confrontation with this dilemma. In densely populated areas where theft is common, cultivators often protect their gardens by using security devices. While these devices can help ward off thieves and other predators, they can also attract other problems. By way of illustration, consider this item, culled from the same California newspaper.

## Alarming Way
## To Get Caught

A marijuana grower's ingenuity proved to be his downfall Sunday when his homemade burglar alarm led sheriff's deputies directly to his illegal patch of the plant.

Officers today said a caretaker in the A. Road area reported hearing a burglar alarm sounding somewhere nearby.

Deputies followed the sound into the woods where they discovered eight tall marijuana plants surrounded by an alarm system.

The deputies traced the alarm wires to a small house where narcotics officers later found evidence of more marijuana cultivation in the basement of the home.

The resident was not at home and no arrests were made.

Officers said they think Sunday's rainfall triggered the alarm.

The cultivator's dilemma has no apparent satisfactory resolution. The more environmental elements a plant is provided with, the more it will produce. However, any compensation made for increasing the availability of these elements will likely compromise the plant's seclusion.

The more seclusion a plant is provided in its cycle of growth, the more likely it

is that the plant will reach maturity. However, any compensation made for seclusion compromises the availability of environmental elements needed for growth.

This dilemma affects every aspect of the cultivation cycle and is governed by the law of "the more . . . the more . . . ." The more plants a cultivator attempts to nurture, the more difficult the dilemma will be to resolve. Were it not for this dilemma, the cultivation of cannabis would be no different than any other horticultural endeavor attempted by mankind.

# Chapter 3

# Evolution of Technique

The cannabis plant needs an available and sufficient supply of environmental elements for growth. These elements are light, temperature, water, soil, and nutrients. The plant also needs seclusion. Providing the plant with these mutually exclusive requirements is the cultivator's dilemma.

The sinsemilla technique is a production technique which evolved in response to this dilemma. By employing this technique, cultivators are able to produce more substance value—THC—with less resources—environmental elements and seclusion.

The sinsemilla technique evolved with the escalating forces of Prohibition. At the turn of the century, cannabis was cultivated in large plots in prime agricultural environments for its ability to yield fiber. With the advent of Prohibition, cultivators were forced to locate their gardens in smaller, more marginal environments for its ability to yield THC. As a result, cannabis is no longer cultivated in the rich, fertile soil of the valley floor. Rather, it is located in small, remote environments where passers-by are not likely to see it growing.

Because these gardens were forced into small, out-of-the-way locations, cultivators have fewer plants to nurture. With fewer plants to care for, cultivators are able to give each plant individual attention. This individual attention is the basis for an intensiveness of technique unmatched in horticultural history.

Through intensive care, cultivators are able to increase the substance value of their crop by 1) increasing the production of each plant, and 2) improving the quality of produce each plant will yield.

As the forces of Prohibition become more effective in detecting and prosecuting illicit gardens, cultivators are forced to become more efficient and produc-

tive in the cultivation of fewer plants in smaller gardens. This stress enforces a survival-of-the-fittest situation in which weak, inefficient gardens are eliminated and strong, efficient ones survive.

This process of elimination makes technique an extremely important aspect of cultivation. Inefficient techniques, if successful at all, are likely to yield a cannabis product of inferior quality. In addition, poor technique is often punished by insect infestations, diseases, thefts, or any number of other catastrophes. Efficient technique, however, not only increases the chances for survival, but also is more likely to yield a cannabis product of superior quality.

Consumers appreciate this evolution of product quality, because it enables them to consume less cannabis and enjoy the effects it produces more. This appreciation is reflected in the marketplace, where quality cannabis sells for 500% to 600% more than does inferior cannabis produced by agribusiness concerns in foreign lands.

The sinsemilla technique, therefore, enables the cultivator to reap benefit from small gardens in marginal environments. Indeed, through this technique, a small garden plot can become the functional equivalent of a large garden plot.

To illustrate how this sinsemilla technique evolved, I will take you to the epicenter of cultivation activity in Northern California—the EFU Ranch.

There are many outrageous tales about the cultivation of cannabis; so many, in fact, that one tends to ascribe them all to the mythical. In Northern California and Southern Oregon, I often heard whispers of this place called the EFU Ranch. EFU, incidentally, is the acronym I made up to disguise the real name—such are the exigencies of researching underground phenomena. The rumors I listened to detailed certain outrageous activities committed by the residents of the EFU. For example, there were the harvest parties, with thousands of people, and rock and roll bands, and . . . .

In the summer of 1980, while traveling in one of the more notorious cultivation areas of Northern California, I met an individual who mentioned the EFU. He said, "I got my seeds from the EFU, so I know they have to be good." Seeds are tangible objects. I asked for more.

Through persistent pleading, and a few beers, I was given the name of a man to contact. I will call him Papa Lion. Papa Lion was a big man with a friendly disposition. After some preliminary discussion on the telephone, and some more detailed discussion over beer, he agreed to take me to the EFU. Papa Lion's son, Lion Cub, lived there with his family. It would be okay.

Papa Lion picked me up early one morning and then cruised into a nearby store for beer and ice. He then guided the wheezing old American car to a secondary highway, and we meandered off into one of the numerous valleys in the area. When the sun came over the ridgetops, we rolled down the windows and popped a couple beers. It was going to be a hot one—a dog day of summer. It would drive the mountain folk off the ridges into the cool waters of the river below.

Papa Lion turned off the secondary to a gravel road. As we climbed toward the ridgetops, he pulled more beer from the cooler and began talking about the area. "There's nothing left around here but scrub growth," he said, "just leftovers from the great logging days of the past. You see, this area once provided the big cities to the north and south with lumber. Now its all gone. All we have left is the few isolated areas of redwood preserves, and scrub growth. Those trees you see have no commercial value. There's some tan oak, and white oak, and a lot of madrone. Not much here for folk to make a living on, anyways."

Up on the ridgetop the road deteriorated into a jeep trail. Two beers later, we began winding down into a small, picturesque valley filled with the green fog of dense tree cover. Half way down, the temp light flashed red. Papa Lion pulled to a halt and climbed out to relieve himself. Because of the amount of tree cover, I could see nothing in the valley. But Papa Lion grunted in satisfaction, honked the horn twice, and released the parking brake.

At the bottom, we rounded a corner and came to a checkpoint. A small trailer sat on one side of the road, and two old cars were parked on the other. Two sleepy-looking mountain boys stood shirtless in the dust. It was the end of the road.

After a lengthy ritual of introduction, in which several beers were consumed and a pipe passed, I explained my interest, and took a few oaths. Other ranch hands began to appear from different trails under the trees. After another lengthy conference, in which everybody expressed doubts as to my real intentions, I was approved. We hiked up one of the dusty trails to a group of buildings. These buildings formed a credible replica of a frontier village, complete with bank, cafe, hotel and jail.

We all sat down on the boardwalk of this Dodge City and opened beers from Papa Lion's diminishing supply. After a pipe had made its circuit, Lion Cub began to relate the story of growing sinsemilla in the hills of Northern California. While the Dodge City setting seemed a bit peculiar, I soon realized that I was sitting with outlaws of the New West. I became acclimated and considered everything to be appropriate.

In the mid-sixties, Lion Cub's story went, the metropolitan areas of Los Angeles and San Francisco began to experience the heat of social confrontation. As a result of this unrest, a wave of people emigrated to the pastoral countryside of the hill country to the north. Among these emigrants were the founders of the EFU. While they had escaped the confrontation of the cities, they found friction in the hills. Perhaps it was the emigrants' long hair; Lion Cub did not seem to know for sure.

Anyway, they found themselves in what amounted to a foreign country without any way of making a living. The hill country had long since been mined of natural resources. Gone were the massive stands of redwoods that once covered the land; gone too were the minerals in the earth and the fish in the sea.

All that remained were tourists, and competition for them was fierce.

Yet many of these emigrants were veterans of the rebellion in the city. Part of this rebellion was the illicit use of cannabis imported from Mexico and Columbia. The EFU hands had saved their seeds.

In the beginning, the ranch hands lived communally in the center of their land. As they were among the first immigrants to settle in the area, they encountered a good deal of scorn and ridicule from the natives. As Lion Cub described it, "It was the rednecks against the hippies."

This confrontation quickly developed into a feud of sorts, with both parties staging raids upon the opposition. Lion Cub recalled some of these adventures, and all nodded their heads in agreement. "The rednecks would come out and push one of our cars off the ridgetop. We would retaliate by going down into the valley and planting marijuana everywhere. We planted it at the courthouse, and along the highway and gave seeds to everybody."

To survive in the countryside, the ranchhands planted a large garden. Part of this garden was a large plot of cannabis. In photographs produced by Lion Cub, one could see several tall plants surrounded by deer fence. Said one of the hands, "We didn't plant this crop for money. We just wanted our own stash." That being the case, I judged them to have a rather healthy appetite.

When the plot was harvested, the hands decided to have a harvest party, and invited like-minded immigrants from the surrounding hills to join them in celebration. To this celebration came an entrepreneur with a suitcase full of cash. Said Lion Cub, "He offered us $1,000 a pound. Boy did we celebrate then; YAHOO!!"

The EFU survival garden proceeded happily for a couple of years, with the ranch gaining in size each year. With each harvest came another celebration. And with each celebration came fame. Because of this fame, the ranchhands found it necessary to erect a gate and post "No Trespassing" signs.

Finally, with the largest survival garden of them all going full tilt in the middle of the ranch, the Marijuana Eradication Team came. "You can't grow like that anymore," said Lion Cub. "You've got to hide everything really well now. The Man uses airplanes and can see really well and gets federal money to come in here and bust us. Hell, we don't even live together anymore. We all got our own little corner of the land, and we just live peaceful, respectable lives now."

By then, Papa Lion's beer had been consumed, and the atmosphere was getting a bit melancholy. Lion Cub said, "Come on, we'll give you a little walking tour of the ranch."

This walk was most amazing. The ranchhands had built a system of trails that covered the hillside in a spiderweb-like maze. Several times we crossed steep ravines on swaying foot bridges. "All our building materials we had to carry in on foot," said Lion Cub, "so we built these bridges to make it easier."

During the tour, I visited two dwellings. Near each dwelling was a small plot

Figure 8: SUSPENSION BRIDGE AT THE "EFU" RANCH

of cannabis—individual chips from the large survival garden of the sixties. Yet each of these gardens was intensively cultivated and well hidden. Should the police decide to raid these gardens, they would have to hike many miles for a few plants.

34

While the ranchhands lost productivity in scaling down the large garden, they strived to make up the difference by improving their technique. Indeed, they talked of developing a super plant. When I asked Lion Cub what a super plant was, he said, "We can grow plants that will yield three pounds of seedless bud per plant. From the air though, it just looks like one plant. And it's the best seed stock we can find. In the off season, we travel around and look for good seed strains."

As I was leaving, Lion Cub summed up the feelings of all the ranchhands by saying, "Our goal these days is to make it easy for the Man to go a little further down the road. There's always some newcomer with 500 plants sitting in one place just waiting to be busted."

The EFU dispelled many of the feelings I had developed toward this legendary bunch of outlaw farmers. Indeed, they appeared to be hard working individuals, deserving high marks for ingenuity. Nonetheless, they were responsible, in a large way, for Northern California's becoming known for its illicit crop of sinsemilla.

There are many people who believe the reason this area became so notorious is because of its climate. Actually, the climate is not all that good. In fact, moist Pacific storm fronts move through the area nearly every year around harvest time, molding flowers and dampening spirits.

What does make Northern California so attractive is the scrub growth—the oak, madrone, and chaparral that have no value in the marketplace. It provides excellent cover for small, intensively cultivated crops of sinsemilla.

Today, the big gardens grow elsewhere, in areas that do not have the reputation. In Northern California, there are federal money, and low flying airplanes, and Marijuana Eradication Teams. Only the small, individual-sized plots have a resonable chance to survive.

# Part Three

# Microclimate Systems

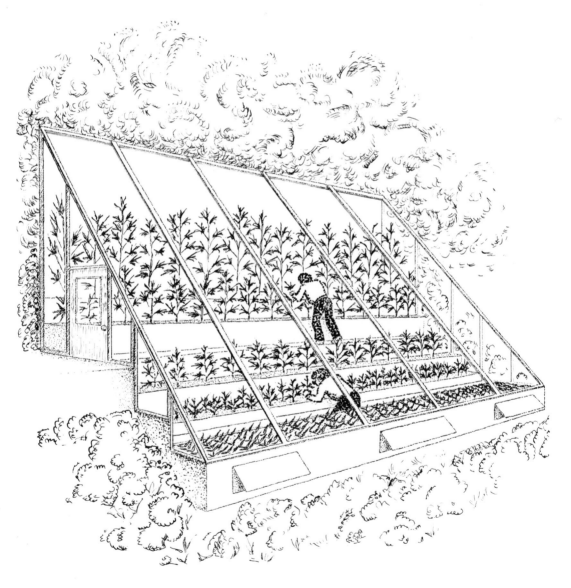

Figure 9: GREENHOUSE MICROCLIMATE SYSTEM

# Microclimate Systems

The growth of cannabis is governed by the interaction of the plant's genetic endowment (or genotype) with elements in the environment. To improve this interaction, sinsemilla cultivators establish microclimate systems. These systems increase the plant's ability to synthesize elements from the environment into new plant tissue. The more elements a plant can synthesize, the more sinsemilla flowers it can yield. Productivity, therefore, is determined by how well sinsemilla cultivators manage these microclimate systems.

I use the expression "microclimate system" because it is the one expression that adequately describes the sinsemilla garden.

I visited many of these gardens while researching this cultivation technique. In addition to regions where cultivation activity has become legendary—like the hills of Northern California—I traveled to other, more unlikely garden settings. For example, I visited a garden secreted midst the Spanish-tile rooftops of downtown Santa Barbara; one confined to a converted chicken coop near Santa Rosa; one hidden in an old barn in the San Joaquin Valley; and one in the basement of a tract house in suburban Seattle.

Each of these gardens was a unique manifestation of some cultivator's facilitating the interaction of plant and environment. In other words, each of these gardens was an expression of an individual cultivator's work.

In other horticultural endeavors, similarities of technique can be recognized from garden to garden, county to county, and state to state. For example, plants may be placed in neat and exact rows to facilitate the use of machinery and manpower. These similarities also stem from widely disseminated information and relative uniformity of farmland. In the secret gardens of sinsemilla, however, each and every garden is a unique entity. Indeed, they are like fingerprints—no two gardens are the same.

When it came time to describe these gardens, I found this diversity somewhat disconcerting. How, I wondered, could I describe gardens which vary in appearance from location to location, and person to person. To resolve this writer's dilemma, I concentrated on identifying characteristics common to all sinsemilla gardens. I found two such characteristics.

Sinsemilla gardens are inevitably confined to small spaces, environmentally and climatically unique to the surrounding area. Cultivators select these small spaces to take advantage of favorable access to the elements of growth and to insure seclusion. In other words, these small spaces are selected because they resolve the cultivators' dilemma. In the lexicon of the earth sciences, these small unique areas are called "microclimates."

Within each microclimate are incorporated the environmental elements necessary for photosynthetic metabolism. These elements are light, air, heat, water, soil and nutrients. While these elements may be present in many natural settings, they are rarely present to the degree required by intensive cultivation. For that reason, sinsemilla cultivators establish "systems" to insure the continued availability of elements to the plants. Hence the term "microclimate systems."

Through such practices as irrigation, mulching, supplemental lighting and light interruption, cultivators control their microclimate systems. This control enables them to increase the productivity of cannabis by 1) increasing the rate of growth, 2) regulating the cycle of growth, and 3) extending the duration of growth. In addition, microclimate systems enable cultivators to control those aspects of the finished product—taste, bouquet, and appearance—which constitute quality.

To control microclimate systems, however, cultivators must be technicians of many skills. The interaction of plant with environment must be justified with forces both natural and human. These forces are unique to each individual situation. For that reason, the cultivator is the single most important element in any microclimate system.

Because of the value society places on sinsemilla, cultivators take this responsibility quite seriously. In fact, the microclimate systems I have visited reflect the best side of each cultivator.

While visiting one garden in the mountains of Mendocino County, for example, we were introduced to a couple living with their young child in circumstances which could only be described as extreme squalor. Their home, a pickup camper set on the ground, was shared with chickens, dogs, cats, flies, and fleas. Their sewage disposal system seemed to consist of hungry dogs. They were, as the expression goes, "roughin' it." Yet when they took us into their garden, we were treated to another aspect of their personality.

Down in a nearby gulch, the family had established a string of mini-plots which ran through a grove of madrone and oak trees. Each of these plots consisted of a large hole in the ground which was filled with rich, black earth.

38

From these holes grew three or four large *Cannabis indica* plants which, at the end of the season, would produce more than a pound of flowers per plant. Water lines crisscrossed the grove and branches were pruned from overhanging trees so that the light shined only on the plants themselves.

When we filmed this project in its grotto-like setting, it was like shooting a living rendition of a Van Gogh landscape, as the activity was clearly defined in the crisp lines of energy fields. All of the better cultivation activity I have photographed has this intensity, and it is another reason why the term microclimate system seems more appropriate than does the term garden.

To describe these systems, I have divided them into constituent parts. The first part, Chapter 4, details the environmental elements necessary for plant growth. The second part, Chapter 5, describes the three categories of location—outdoors, indoors, and greenhouses. By considering these aspects of cultivation as a microclimate system, the reader can gain an understanding of how sinsemilla cultivators produce more cannabis of high quality while growing fewer plants in smaller plots.

# Chapter 4

# Elements of Growth

Certain environmental elements must be present for the growth of plants. These elements—air, light, heat, water, soil and nutrients—are ingredients of photosynthetic metabolism. Because these elements are fundamental to plant growth, they provide a means by which cultivators affect the growth rate and productivity of plants.

Cultivators affect growth rate by incorporating these elements into on-going systems which channel elements to plants. When all of these elements are in sufficient and available supply, plants can realize their optimum rate of metabolic activity and produce the maximum amount of plant tissue.

Incorporating these elements into an on-going system is a technically precise task. Because cultivation is restricted to small, out-of-the-way locations, this task often creates logistical dilemmas of monumental proportions. Nevertheless, plants will not grow when one of these elements is missing or not available.

In some respects, the task of managing elements of growth is analogous to managing elements of fire: To increase the intensity of fire, one merely adds more fuel and more oxygen; to reduce intensity, one reduces their availability. The ability to control these elements of fire is manifest in devices like the acetylene torch, which forces both oxygen and fuel through a small opening to produce a very intense fire.

Sinsemilla cultivators strive for this intensity in the management of elements within their microclimate systems. By providing all of the elements needed for growth, and then making them available to plants, cultivators increase the intensity of the plants' rate of growth. By increasing this intensity, plants that would—under normal cultivation techniques—produce three ounces of flowers can be made to produce over three pounds of flowers. That is a 1600% increase in productivity.

In the following description of elements of growth, I have omitted the element air. This element provides plants with carbon dioxide and oxygen. In most cultivation situations, air is present in sufficient and available supply; in certain controlled environments, however, air becomes a difficult logistical consideration.

While filming a light-room in the Puget Sound area (color plate #9), I was nearly overwhelmed by the thick aroma of *Cannabis indica* in the air. In this enclosed environment, the plants had to—figuratively speaking—fight for their breath. The resident cultivator said that air was her big problem, "what with the neighbor being so close and all."

Another microclimate system, this one located in a greenhouse, supplemented air with periodic infusions of carbon dioxide. The resident cultivator, a pre-med student, claimed that the plants filled the room with oxygen, leaving no room for carbon dioxide. Other individuals claim to have solved $CO_2$ deficiencies by whispering "sweet-nothings" to their plants.

These considerations notwithstanding, I have omitted air from the list of elements because it is simply a function of circulation; in most cases, it is a minor consideration.

# LIGHT

The ultimate source of energy for all plant growth is the radiant energy of the sun. Radiant energy is transmitted to the earth in the form of electromagnetic radiation. This radiation varies in frequency or wavelength, from cosmic rays on the low end of the spectrum to radio waves on the high end. In the middle of this spectrum are the wavelengths visible to the eye. We call this part of the spectrum light.

When light is split by a prism, it separates into its constituent wavelengths, or colors, which range from the lower frequency blues to the higher frequency reds. These visible wavelengths are the familiar colors of the rainbow. Each of these color frequencies influences a different aspect of plant growth:

Blue and red light waves *influence* photosynthetic activity
Blue and orange/red light waves *influence* chlorophyl development
Near ultraviolet to blue/green light waves *influence* phototropism
Red light waves *influence* photoperiod

41

Plants absorb light primarily from the blue and red spectrums which are on the opposing sides of the rainbow. Light from the center of the frequency spectrum—greens and yellows—is reflected or transmitted through the plant, hence the characteristic green color.

Light is made available to plants from three different sources. First, and most obvious, is the light which is transmitted directly from the sun (or lights on the ceiling). Second, light is reflected from particles in the sky vault like the dust and water particles of clouds. Third, light is reflected from surfaces on the ground.

Light regulates the productivity of plants in two ways: First, the intensity of light affects the rate of growth; second, the period of light affects the duration of growth (or the growth cycle). By controlling the availability of this energy source, sinsemilla cultivators increase productivity by controlling the plants' development and by increasing their rate of growth.

## Light Intensity and Rate of Growth

Green plants convert light energy into chemical energy via the process of photosynthesis. This chemical energy is then used by the plant in building carbohydrate (organic) compounds from air and water. These organic compounds provide energy for the plants' metabolic functions and are the raw material for new plant tissue. The amount—or intensity—of light available for this energy conversion, therefore, is a regulating factor of growth.

Plants convert one to six percent (approximately) of the available light energy into chemical energy. Certain plant species are more efficient at this energy conversion than are others (see color plate #35). Cannabis falls into a category of plants often called "compass plants." These plants orient growth for the most favorable access to light. Because of this orientation, one can look at a plant and tell which direction is south. This growth characteristic is called phototropism— orienting for light—or heliotropism—orienting for the sun.

Among the more energy-efficient species of photosynthetic plants is cannabis. Cannabis reflects the intensity of light energy in its physical growth. When the available light is diffused and weak, plant growth is characteristically long, thin and sparse with productivity limited to light, fluffy flower clusters. When the available light is intense, growth is characteristically short and thick stemmed, and productivity is improved by dense flower clusters.

Because light intensity is so fundamental to the rate of plants' growth and productivity, sinsemilla cultivators are consumed with ways of managing the availability of this energy source. In a fundamental way, cultivators are like oil companies: They take an available source of energy—light—and process it through refineries—photosynthetic plants—and then package it for future consumption.

# Regulating Light Intensity

As with all environmental elements, there can be either too much or too little light for optimum plant growth. When the plants are young, or have just been transplanted, they cannot tolerate the heat produced by intense radiant energy. On the other hand, when the plants are well established and have a healthy rate of transpiration, they can process all the light energy they receive.

Most cannabis varietals cultivated here in the United States possess the genetic intelligence for growth in tropic or subtropic climates. Because of this intelligence, they are capable of processing intense light energy. For this reason, sinsemilla cultivators are primarily consumed with increasing the availability of light energy to their plants.

As mentioned, there are three sources of light in the environment:1) direct from the source,2) reflected from particles in the sky vault, and 3) reflected from surfaces on the ground. To regulate the intensity of light, sinsemilla cultivators orient their plots and plants so as to achieve the optimum utilization of these light sources.

*Direct from the source:* The most direct light is that which radiates from the source. Cultivators increase the availability of this light in two ways: They locate their microclimate systems in favorable geographical positions, and they orient the plants so that the maximum amount of leaf surface is exposed.

South-facing parcels of land have a more favorable access to light than do north-facing parcels (see figure #10). In addition, slopes increase light intensity

Figure 10: SOUTH FACING SLOPES

by creating a right angle to the source. Higher altitudes also increase intensity by virtue of the presence of thinner air. The optimum orientation for a microclimate system, therefore, is high on a south-facing slope.

A good example of this principle is the dwarfed *indica* plants in color plate #8. This photograph was taken on a late summer evening. While plants down in the valley floor are deep in shadow, these plants are still processing light energy into chemical energy.

Cultivators also orient the physical shape of the plant toward the source of light. In figure #2, a plant has been bent into an arch and secured to the ground so that the bottom branches receive more light than they would were the plant allowed to grow straight. In figure #4, the plant has been espaliered against a wall to increase exposure to both the direct light from the sun and the reflected light from the wall behind it.

*Reflected from particles in the sky vault:* Cultivators do not have the ability to control particles in the sky vault as they do other factors in the environment. In certain circumstances, however, the presence of moisture particles in the air provides an additional source of light.

In the Pacific Coastal Range, for example, moisture from the ocean fills the air with haze. This haze increases the distribution of light, and thereby aids the photosynthetic activity of plants. This atmospheric condition became so familiar to sinsemilla cultivators that a certain strain of potent cannabis was named after it—"Purple Haze."

*Reflected from surfaces on the ground:* Cultivators do have the ability to increase light intensity by utilizing surfaces on the ground. This reflected energy affects growth in two ways: Light reflected from dark surfaces is in the longer wavelengths which stimulate leaf growth; light reflected from bright objects is shorter wavelength radiation which stimulates flower growth.

There are many kinds of surfaces utilized as reflectors. In color plate #8, for example, one can see that the earth itself is an excellent source of short wavelength radiation. In color plate #9, the indoor environment has been lined with reflective aluminum foil, thereby increasing the efficiency of the metal halide lamps, and reducing the electricity bill.

By increasing the availability of light, cultivators affect productivity. As a result, a good deal of ingenuity is expended on orientation of plots, plants, and surfaces toward this end. I found one of the better examples of this ingenuity in Mendocino County.

This microclimate system (color plate #15) was situated immediately below a south-facing sandstone cliff and sloped steeply down to the shimmering waters of the Eel River. It took advantage of the direct rays of the sun striking the surface plane at right angles; it took advantage of the reflected light from moisture in the air; and it took advantage of the reflected light from the sandstone cliff, soil, and river. Because of the intensity of all that light, the plants were able

44

to synthesize a lot of plant tissue, and the cultivators were able to realize the maximum rate of return on their ingenuity.

## Photoperiod and Cycle of Growth

Photo period is the relationship of daylight to darkness in a day. This relationship of light and dark changes with the earth's rotation around the sun. The annual variations in this photo period are defined by the winter and summer solstice, and the vernal and autumnal equinox. These broad changes in the relationship of light and dark are called seasons.

In figure #11, one can see how these seasonal variations affect the availability of light in the Northern Hemisphere. When the sun is at its high point on the summer solstice, there is more daylight than darkness in a day. When the sun reaches its low on the winter solstice, there is more darkness than light in a day.

Figure 11: SEASONS OF THE SUN IN NORTHERN HEMISPHERE

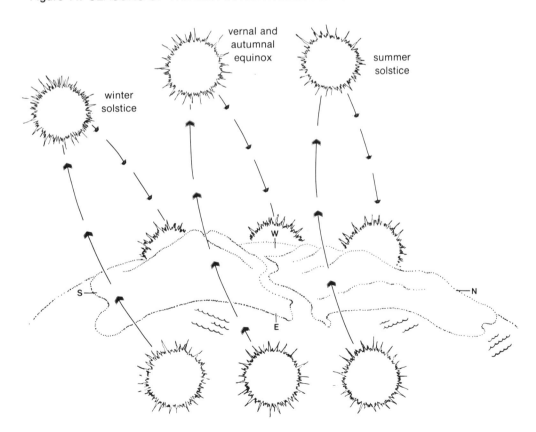

On the equinox, there is an equal amount of daylight and darkness in a day.

While this ever-changing photoperiod affects all living things, its effect upon plants is especially acute. Plants have a genetically-fixed response to light changes in the environment. A single light-sensitive pigment—called phytochrome—detects these seasonal changes in light and triggers a crisis in the plants' growth. The plants respond by going into the appropriate phase of growth.

From the spring equinox until the summer solstice, the period of light increases daily. Plants sense this change and respond with vegetative growth. As the autumnal equinox nears, the period of dark increases rapidly. The plants sense this coming of winter and respond by going into the florescent reproductive growth.

The degree to which plants respond to changes in photoperiod is determined by the plants' variety, age, and sex. Cannabis varietals from higher latitudes respond more quickly to these changes than do varieties from equatorial regions. Older plants respond more quickly than do younger plants. Male plants respond more quickly than do female plants.

Because cannabis plants are so profoundly affected by the changes in photoperiod, sinsemilla cultivators often find it advantageous to control or regulate this feature of light energy. This control enables cultivators to determine the sex of their plants by simply cutting back on the photoperiod to 12 hours of light per day (equinox). It also enables them to extend the flowering cycle or revert from one cycle to another—as is often done in the case of cuttings taken from flowering female plants.

This control enables individuals to increase the productivity of their micro-climate systems markedly. When the sinsemilla technique was in its initial stages of evolution, cultivators would plant x amount of plants in their plots. After several months of being nurtured, $1/2x$ would reveal themselves as male, and consequently be removed from production. Today, cultivators transplant pre-sexed plants into their plots, thereby increasing efficiency by 100%.

## Regulating the Photoperiod

Cultivators regulate photoperiod by controlling plants' access to light. When the cultivator has determined which phase of growth the plants should be in, light is made available in the photoperiod of the corresponding season. For example, when cultivators sex their plants, the photo period of the autumnal equinox (12 hours of light) is replicated. Once assured of the plants' gender, the females are then shifted back into vegetative growth by establishing the photoperiod of summer (18 hours of light).

Exerting this control, of course, is easier in some environments than in others. Cultivators with microclimate systems indoors have this control at the flick of a light switch. In less controlled environments, this control requires a little more ingenuity.

I experienced a good example of this ingenuity in a converted chicken coop in Sonoma County. The resident cultivator, a student at a nearby college, had converted the front half of the chicken coop into a home, and the rear portion into a greenhouse.

Inside this greenhouse, the cultivator had erected a framework along the translucent fiberglass ceiling so that he could, at will, draw black plastic across the ceiling and restrict the flow of light. In June, he began pulling this black plastic across the ceiling and restricting his plants to 12 hours of light per day. In September, when the Marijuana Eradication Teams were beginning their annual fall harvest, this cultivator was "out-of-the-ground" and off to school.

By controlling the availability of light to their plants, sinsemilla cultivators increase productivity in two ways. Through increased light intensity, plants are able to achieve their maximum metabolic rate. Through regulated periods of light, plants are directed into the most productive phases in their cycle of growth.

These controls are also important because most of the cannabis varietals under cultivation in the United States are genetically keyed to growing conditions in other, more sunny climates in the world. By exerting these controls, cultivators are able to make up in intensity and duration for what is lost in latitude and attitude.

# HEAT

As an element of the environment, temperature regulates nearly all of the physical and chemical processes of plant growth and development—from the germination of seeds through florescence and fruitation. In these plant processes, the most important aspect of temperature is heat.

The source of heat in the environment is the radiant energy from the sun. This heat is transferred in the environment four ways: 1) Physical heat conduction is the transfer of heat created when fast moving molecules collide with slower moving ones. 2) Apparent heat conduction is the transfer of heat by convention currents. 3) Evaporation is the transfer of heat through the evaporation of water. 4) Thermal radiation is the transfer of heat through radiation.

47

# Heat and the Rate of Growth

Cannabis varietals cultivated for THC have, generally speaking, genotypes keyed to growth in the warmth of the tropics. They are, in character, heat loving varietals unfamiliar with the climate of our northern latitudes. If there is enough heat (70° F.), seeds will germinate, and plants will grow (75°+ F.) and produce flowers (60°+ F.).

For cultivators, there are two important measurements of temperature in the environment: air temperature and soil temperature. In incorporating heat into a microclimate system, both of these temperature considerations are important.

Air temperature is a convenient way of measuring the internal temperature of plants. Unlike humans, plants have no openings suitable for the insertion of thermometers, so we measure internal temperatures by taking measurements of the surrounding air. The temperature of a plant is extremely important because it regulates the rate of cell division, distribution of mineral nutrients, and flow of the transpiration stream throughout the plant. When air temperature is warm enough, plants are able to realize the maximum rate of metabolic activity.

Soil temperature affects the rate of growth by controlling the availability of mineral nutrients to the plant growth above the ground. There are two important aspects to this temperature control: 1) the effect of heat on the biological decomposition of organic matter in the soil; and 2) the effect of heat on the solubility of these nutrients and the flow of the transpiration stream through the root system

Organically rich soil is inhabited by micro-organisms called decomposers. Through their collective hard work, decaying organic matter is converted into inorganic mineral nutrients. The rate of this decomposition is regulated by the temperature of the soil. Nitrification, for example, does not begin until the soil temperature reaches 40° F., and does not reach the optimum rate until temperatures reach 80° to 90° F.

In addition, soil temperatures govern the rate at which these mineral nutrients become soluble in the soil water, and the rate at which this solution flows through the root system. Warm temperatures enhance this flow by expanding the root xylem; cold temperatures restrict this flow by contracting the root xylem.

# Regulating Heat

Because heat is so fundamental to growth and productivity, sinsemilla cultivators go to great lengths to insure adequate temperatures when establishing

their microclimate systems. These temperature requirements vary from varietal to varietal, and also with the plants' stage of growth. Varietals from equatorial Columbia, for example, would quite naturally prefer warmer temperatures than would varietals which evolved in Mexico. Young cuttings and transplants prefer cooler temperatures than do mature plants with well-established root systems.

Like all other elements, there can be too much heat or too little. For that reason, cultivators establish systems to regulate temperature, and thereby enhance the growth rate of plants.

*Increasing Environmental Temperatures:* Because most varietals come from warmer climates, cultivators are most likely to find themselves in need of increasing the availability of heat in their microclimate systems. The obvious method of increasing temperatures is by taking advantage of radiant energy. As this energy source also provides light, the two elements are often considered as one.

Another way of increasing temperatures is by taking advantage of favorable characteristics in microclimates like "heat islands." Heat islands are objects— rock formations, buildings, etc.—that collect heat during the day and radiate it back during the night. In color plate #15, for example, the large sandstone cliff towering over the plants is an excellent source of heat during the increasingly long nights of autumn.

Slopes also provide favorable heat characteristics in a microclimate. At night, air flow is determined by the convection currents created by a warm earth and a cool atmosphere. The cold air from the atmosphere descends the slopes to the valley floor to replace the air rising from the radiating earth. This movement of air protects growth on the slopes from all but the most severe of frosts.

In especially cold climates, cultivators often make alterations in their microclimates to protect plants and conserve heat. The most frequent alteration is the use of translucent plastic shelters. They are season extenders in that they enable cultivators to start plants earlier and extend their growth longer into the season.

The amount of heat stored in soil depends upon color, water content, and cover. These controlling factors provide cultivators with means of regulating temperatures and affecting growth. In figure #12, one can see how mulches are used in regulating these controlling influences of soil temperatures.

Another popular way of increasing soil temperatures is through the utilization of vessels. When a soil system is confined to a vessel, the soil temperature will more closely resemble the air temperature. When the air temperature is too extreme, these vessels can be protected with insulating mulches or carried indoors.

*Decreasing Environmental Temperatures:* In certain stages of growth, plants cannot tolerate high temperatures. Young seedlings, transplants, cuttings, and indoor plants being acclimated to the out-of-doors require moderate temperatures. For sinsemilla cultivators, this requirement is perhaps the easiest

49

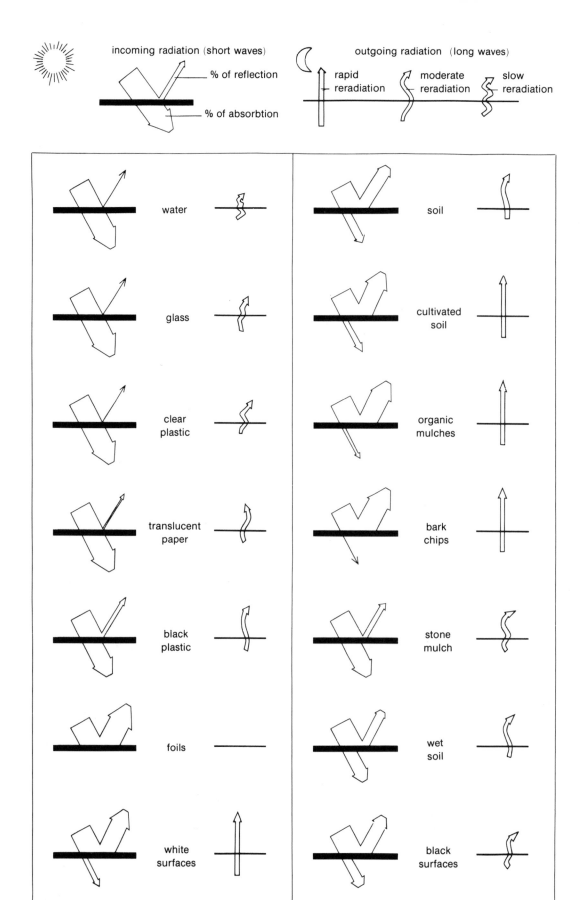

**Figure 12: The effects of various mulches and surfaces on soil temperatures.**

of dilemmas to resolve. By reducing exposure to radiant energy, adding water, or applying mulches, temperatures are moderated at need.

By controlling those aspects of the environment that affect temperature, sinsemilla cultivators have become adept at increasing the heat budgets of their microclimate systems. If all of the other elements necessary for growth are present, the plants respond to this increased warmth by processing more inorganic mineral nutrients into more sinsemilla flowers.

While there is a point at which temperatures can be too hot, most cannabis varietals are genetically keyed to growth in temperatures warmer than are found in the United States.

One project I visited took advantage of many microclimate features in increasing temperatures. This project was situated on a south facing slope near a dormant volcano in Northern California, and often had temperatures exceeding 115° F. I accompanied the cultivator on his rounds early one morning. He began watering at first light. The plants, *indica* varietals from Afghanistan, were dwarfed in paper buckets, then dug into the ground to prevent excess evaporation.

By 9 am, we were gasping from heat in the shade of a tree. Around us seed pods from poison oak snapped like popcorn in a hot skillet. I asked him about too much heat. He said, "As long as I water and feed them daily, and that means four in the morning, they grow like crazy. But if I ever miss my rounds, they wilt and the grasshoppers swarm in and destroy them."

# WATER

Growing plants consist of approximately 90% water by weight. The availability of water, therefore, has a profound regulating effect on the growth rate of plants. There are three ways in which water affects growth:

First, water is the solvent which picks up mineral nutrients in the soil and, through the flow of the transpiration stream, carries them to the food-processing factories located in the leaves. In addition, the by-products of photosynthetic metabolism and physical impurities are carried away when water is transpired through the leaves back into the atmosphere. When water is not available in sufficient supply, plants cannot receive nutrients nor rid themselves of impurities.

Second, water provides the turgor for plant cells. Turgor is the pressure

required to maintain the rigidity of cells. When there is not a sufficient supply of water available, turgor is lost, causing the stomates to close, thereby restricting the flow of the transpiration stream. Loss of turgor, obviously, is indicated by wilting leaves and a pronounced droop in the plants' outlook.

Third, water is a nutrient required in the energy-conversion process of photosynthesis. While only 1% (approximately) of the flow of the transpiration stream is used in synthesizing carbohydrate compounds, it is an extremely important constituent of metabolism. When plants are stressed from lack of water, energy-conversion slows and the growth rate diminishes.

For every part of dried plant matter produced, plants must transpire approximately 500 parts of water. The significance of this ratio is not lost on sinsemilla cultivators: The more water transpired by the plants, the more plant matter they will produce. For this reason, cultivators establish systems which enable them to control this element.

## Regulating Water

The regulatory functions of water availability determine, to a great extent, productivity. As with other elements, there can be too much water, or too little. The water requirements of plants are determined by environmental factors like soil conditions, temperature, wind, atmospheric humidity, and light intensity.

In addition, the phase of growth determines how much water plants can process. Small seedlings, young cuttings or fresh transplants, for example, do not have the root capacity to process a lot of water. However, with mature root systems and optimum environmental conditions like hot, dry air, cannabis plants may easily transpire more than their own weight in water during the course of a day.

By manipulating various aspects of the environment, sinsemilla cultivators can either increase or decrease the flow of water through the transpiration stream. There are five aspects of the environment which affect transpiration flow: 1) radiant energy, 2) relative humidity, 3) temperature, 4) wind velocity and 5) soil moisture content. By regulating these aspects of the environment, cultivators are able to control the plants' requirements for water.

*Reducing Water Requirements:* When plants are unable to process a lot of water, as with cuttings, transplants, etc., or when water is not available in the environment, as happens when a well goes dry, cultivators must reduce the plants' requirements for water.

There are many ways this need can be reduced by making basic alterations in the environment. The obvious alteration is by removing the plants from the direct exposure to radiant energy, thereby reducing air temperature. If enough

Figure 13: DOUGHBOY POOL (photo by California Attorney General's Office)

water is available, it can be used in reducing air temperature and increasing humidity through the exchange of evaporation. Another effective way of reducing the need for water is by utilizing wind screens to block the evaporative effects of moving air across the plants. Soil mulches also provide an effective means of reducing soil temperatures (see figure #12).

The best example I have seen of regulating water flow in a microclimate system is in the photograph on the cover of this book. The new cutting in this illustration has no roots as yet and therefore can only process moisture through its leaves. To reduce the need for moisture flow until such time as roots develop, the cultivator established an enclosed microclimate with a high relative humidity. In this environment, the plant can fulfill all its water requirements by breathing the moist air of the enclosed environment through its leaves.

*Increasing Water Requirements:* When water is available in the environment, and plants have mature established root systems, cultivators strive to increase the flow of water through plants by increasing the plants' need. Cultivators increase water requirements by regulating those aspects of the environment that affect the flow of the transpiration stream.

The most obvious way of increasing water requirements is through increasing temperatures by utilizing more radiant energy. Reducing relative humidity by increasing wind flow and mulching topsoil (figure #12) to increase soil temperatures are also effective techniques in increasing the flow of water through plants.

Because of the value of their plants, cultivators quickly become cognizant of those environmental factors which influence the flow of the transpiration

53

stream. The more water a plant transpires, the more dried plant matter it will produce when harvested.

## Water Systems

All water systems have, as their foundation, a reservoir and water lines. Water must be stored and available for use. If the garden is near a water system, these logistics are relatively easy for cultivators to deal with. But if the garden is out in the country, water and storage are another matter.

In figures #13 and#14, one can see how various solutions to this problem have been resolved in the hills of Mendocino. However, as these photographs came from the California Attorney General's office, the problem was not resolved in the cultivator's favor.

Since each microclimate system is unique, systems for providing water vary from garden to garden. These systems vary in accordance with basic logistical considerations like microclimate, location and the number of plants. For the sake of convenience, I have divided these systems into two categories: watering by device, and watering by hand.

*Watering by Device:* In recent years, significant developments have occurred in agricultural irrigation systems. These developments range from the

Figure 14: REDWOOD TANK (photo by California Attorney General's Office)

pump and timer systems employed in hydroponics to the drip systems frequently employed in commercial fruit orchards. Sinsemilla cultivators were quick to pick up on these technological advances.

For cultivators, the most notable of these advances has been the drip irrigation system. This system was developed to insure a continued trickle of moisture to the plants without the necessity of somebody's presence. For microclimate systems in remote, inaccessible locations, drip irrigation insures plants a continued source of water without the cultivator's having to hike up the trail. In this respect, the plants are likely to receive more water.

Watering systems based on mechanical devices are studies in compromise. While drip irrigation enables cultivators to water without actually being present, it limits the flow of water to the lowest common denominator of need. Certain plants will not realize their optimum rate of metabolism because they simply do not have enough water. In this respect, drip systems can inhibit productivity.

*Hand Watering:* The most productive kind of watering system employed by sinsemilla cultivators is the "line in hand" system. While this system has the obvious disadvantage of requiring presence, it enables a certain intimacy to develop between plants and cultivators. Through this intimacy, cultivators can water (and feed) each plant according to individual need. In addition, it enables cultivators to monitor the plants' health, activity of pests, and any number of other incidentals resulting from the management of a microclimate system.

In many respects, the "line in hand" method of watering emphasizes the limitations in establishing microclimate systems. A system cannot be located in areas where water is not available. This effectively restricts possibilities, or creates monumental logistical dilemmas.

While flying over Mendocino County in search of material for photographs, I was impressed by the intricate maze of water systems running through the hills. Brilliant blue "Doughboy" pools, white pvc water lines and redwood tanks were everywhere. From the air, these water systems are much easier to detect than are the small camouflaged plots of cannabis.

# SOIL

Soil is the foundation medium for the growth of plants; indeed, half of a growing plant lives confined within the soil. This medium provides support for

the development of root systems; is a reservoir for moisture, air, and nutrients; and is the home for microbacterial decomposers which convert decaying organic matter into inorganic mineral nutrients.

Soil mediums are composed of many different materials: In the outdoors, soil mediums might consist of clays, silts, loams and sands; indoors, mediums might consist of pea gravel, perlite, vermiculite and sand. Cannabis grows in almost any soil medium as long as two soil requirements are fulfilled: good soil texture and a neutral pH.

*Soil Texture:* Texture is the expression used when describing a soil medium's physical characteristics. When you see a farmer reach down for a handful of earth, chances are the soil's texture is being examined. Soil with good texture will break up easily when compacted, and not form hard clods when dry.

The important aspect of soil texture is its effect on the soil moisture content and root development. Soil with good texture will allow excess water to drain while, at the same time, holding enough moisture for normal plant processes. It will allow roots to breathe and grow freely.

To regulate soil texture, cultivators merely add texturizing ingredients to soil mediums. There are many different kinds of organic substances that provide nutrients as well as texture. Rice hulls, manures, composts, and sand are but a few examples. Worms are another popular soil texturizer because they continually work through the soil while processing decaying organic matter. In addition, the worms' castings are a well-balanced source of mineral nutrients.

Cultivators also use man-made substances like perlite and vermiculite. The chief advantage of these materials is that they are light weight and do not compact with frequent watering (and they are available from the local feed and seed). In figure #16, one can see a soil medium being mixed which contains a good percentage of both perlite and vermiculite.

*Soil pH:* pH is the expression used in characterizing a soil medium's chemical make-up. This chemistry is the relationship between acids and alkalines. pH is measured on a scale of 0 through 14, with the lower end of the scale representing acidic conditions (vinegar is 3), and the high end of the scale representing alkalines. On this scale, 7 is neutral.

This soil chemistry is significant because it affects the availability of nutrients. Neutral pH levels encourage microbacterial decomposers which process organic matter into available mineral nutrients. When the soil is too sour (acidic) or too bitter (alkaline), mineral nutrients will not dissolve in solution with soil water and pass into the root system of plants. Instead, they will remain locked in the soil—unavailable.

Cannabis prefers soil mediums with neutral pH. While this pH can be measured with litmus paper, most cultivators I have met rely on their personal senses in measuring soil chemistry. One cultivator remarked that soil pH was ". . . like Chinese sweet and sour cooking. When the sweet balances the sour, the

56

food tastes pretty good; but when one element overwhelms the other, the food tastes terrible. When I examine my soil's chemistry, I look for that kind of imbalance."

Soil pH is corrected with amendments. Acidic soils are neutralized by adding calcium rich substances like lime, wood ash, or even crushed egg shells. Basic soils are corrected by adding rich organic composts containing substances like manures, coffee grounds, etc. With enough patience and amendments, even the most desolate of soils can be made suitable for the growth of plants.

## Soil Systems

Because ideal soil conditions rarely exist to the degree desired by sinsemilla cultivators, they establish soil systems by altering native soil (see figure #15), building soil from "scratch," or by using a "soilless" medium.

As there are millions of small sinsemilla plots around the United States, so too are there millions of soil systems. Each cultivator manages the soil in a way determined by the exigencies of the individual situation. Nevertheless, I have endeavored to categorize these soil systems for the purpose of this discussion. These categories correspond—roughly—to the population density of an area.

*Bio-Dynamic Soil Systems:* In remote areas with small population densities, sinsemilla cultivators often use the same garden plot from year to year. Because of this continued use, they have the ability to establish a soil system that improves with age. This type of soil system is often called "organic or bio-dynamic" because it relies on the decomposition of decaying organic matter as the principal source of mineral nutrients.

Bio-dynamic soil systems are established by altering native top soils. In figure #15, for example, these cultivators are building bio-dynamic soil systems within specific holes. In color plate #7 and #31, one can see the result of these individual systems. The topsoil from the holes was amended with decaying organic matter like mulches, composts and manures. In addition to providing a source of nutrients, these decaying materials improve soil texture.

This type of individual soil system has given rise to a phenomenon called the "super-plant." Because of the Eye-in-the-Sky, sinsemilla cultivators often find it necessary to limit the number of plants in their plots. To make up in productivity for what is lost is numbers, cultivators dig deep holes, four to six feet in diameter, and fill them with rich black earth. These holes promote expansive root development, which quickly becomes manifest in growth above the ground. When three or four plants are transplanted into one of these large holes, a super-plant develops. From the air, these super-plants appear as a single large plant; but from the ground, they are mini-plantations.

57

Figure 15:
PREPARING
THE SOIL

For sinsemilla cultivators, bio-dynamic soil systems offer certain advantages and disadvantages. The principal disadvantage in this system, of course, is the time and effort required in its establishment. Soil must be turned, amendments gathered, and then everything mixed so that the requirements of texture and pH are fulfilled. However, once this system is established, it can be improved with minimal effort and therefore increases in value from year to year.

The advantage of bio-dynamic systems is that they are very forgiving. When texture and pH are correct, cultivators can take off and go to town for a day or two without having to worry about the well-being of their plants. In addition, organically rich soil systems provide plants with well-balanced diets, enabling them to fight off diseases and pests.

*Modified Soil Systems:* In areas with higher population densities, cultivators simply do not have the opportunity to establish bio-dynamic systems which can be used from year to year. Because of the extensive activity surrounding sinsemilla plants, somebody usually becomes cognizant of the fact that "something strange is going on there." For this reason, cultivators in areas with a lot of people consider portability to be of more value than durability. To accomplish this end, they employ the use of vessels in establishing soil systems.

Soil systems confined to vessels are most frequently combinations of topsoil and inert substances like perlite (heat-exploded sand) and vermiculite. These two ingredients improve soil texture, are neutral in pH, and are extremely lightweight. In figure #16, a medium is being mixed which consists of one-half topsoil, one-quarter perlite and one-quarter vermiculite. This medium is used in filling vessels like the one appearing in figure #17, or perhaps greenhouse beds, like those of figure #18.

Soil systems confined to vessels have the obvious disadvantage of being deficient in mineral nutrients. Indeed, when the root systems mature, they will have consumed all of the soil, leaving only perlite and vermiculite. To correct this deficiency, cultivators must continually amend topsoil with nutrient-rich substances like blood meal, worm castings and manures (see Nutrients). When the plants are watered, these nutrients leach down into the roots.

Besides offering cultivators portability, these modified soil systems provide another important advantage. In restricting root development within a vessel, cultivators, in effect, are practicing an ancient Oriental horticultural practice

Figure 16:
PREPARING A
SOIL MIX

59

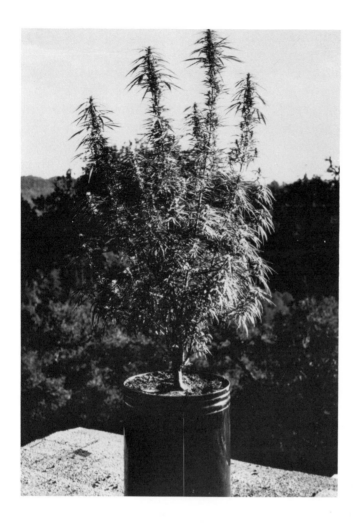

Figure 17:
*CANNABIS SATIVA*
IN VESSEL

Figure 18:
GREENHOUSE
SOIL BEDS

60

known as "bonsai." Restricted root development is reflected in dwarfed growth above the ground. Dwarfed plants are compacted into less area. These compacted plants are much easier to conceal than are the free-growing plants in bio-dynamic soil systems. In color plates #'s 8, 10, 17 and 32 one can see how these dwarfed plants are integrated into native vegetation in a very unobtrusive manner.

*Artificial Soil Systems:* In areas of high population density or adverse weather, cultivators are forced to locate their plots in the more controlled environments of indoor light rooms.

In these environments, cultivators often dispense with the use of soil entirely and resort to inert substances like pea gravel, sand, perlite and vermiculite to fulfill the requirements of their soil systems. This soil system is often called "hydroponics" because the nutrients required for growth must be supplied through mineral salts in solution with water. In these inert mediums, drainage is extremely important because of the build-up of mineral salts.

The principal disadvantage of these hydroponic systems is that they require a lot of attention. To insure that all of the plants' nutrient requirements are fulfilled, cultivators must continually monitor the system in search of imbalances like salt build-ups. In other words, cultivators must assume complete responsibility for the plants' well-being.

The advantage of this system is that it enables cultivation of cannabis in locations where it would not otherwise occur. For cultivators who live in large cities or in areas with adverse weather, this is a profound advantage.

Soil affects the growth rate of plants in many ways. To manage growth, sinsemilla cultivators establish soil systems. Through these systems, cultivators are better able to control those elements of the soil—texture, pH, temperature, nutrients, etc.—that affect growth rate. By increasing their control over these elements, cultivators are able to increase the productivity of their cannabis plants.

# NUTRIENTS

For every ounce of matter produced by growing plants—roots, stems, leaves, flowers and seeds—an ounce of nutrients will have been processed. These nutrients are inorganic minerals and compounds from the environment which plants synthesize into organic plant tissue. As these nutrients are the raw materials of

production, sinsemilla cultivators establish nutrient systems which insure their availability to plants.

There are 16 nutrients known to be essential to plant life. Three of these nutrients—oxygen, carbon and hydrogen—are produced from air and water through the process of photosynthesis. The remaining nutrients are made available to plants through processes in the soil. For that reason, they are often called "soil nutrients."

Soil nutrients are classified by the amounts required for plant metabolism. Nutrients required in the greatest amounts are called "macronutrients" or "trace elements." It should be noted that while some elements are required in greater amounts than are others, all 16 elements are necessary for plant growth. If one of these elements is missing or not available, plant growth will suffer accordingly.

Cultivators spend much of the cultivation cycle arranging plants within environments so that nutrients can be processed into sinsemilla flowers. As a result, nutrients provide the subject matter for many cultivator conversations, much like integrated circuits stimulate conversation between electrical engineers.

*Macronutrients:* There are nine macronutrients required for plant growth. These nutrients are further subdivided into "primary macronutrients" and "secondary macronutrients." Of these two categories, primary macronutrients are perhaps the most familiar because they are often added to soil as fertilizer.

In addition to carbon, oxygen and hydrogen, primary macronutrients include nitrogen (N), phosphorus (P) and potassium (K). One finds these nutrients listed in three digit codes on most commercial fertilizer packages. For example, nutrient fertilizers designed to promote flowering might be labled 0-10-10. This fertilizer contains 0% nitrogen, 10% phosphorus and 10% potassium (available).

Nitrogen is perhaps the most familiar mineral nutrient in cannabis cultivation. This mineral is an important constituent of the organic compounds of nucleic acids, proteins, alkaloids and chlorophyll, and hence of all living plant cells. For this reason, nitrogen availability is a prime determinant in the rate of plants' growth. It determines how fast plants grow, how vibrant and green that growth will be, and how many flowering nodes plants will have when mature. Sinsemilla cultivators have been known to use a lot of nitrogen because it has a direct, visible impact upon the vegetative (or green) growth of their plants.

Phosphorus affects the metabolic functions of photosynthesis, respiration and other biosynthetic processes. In addition, it is also required for the metabolic activity of microbacterial soil decomposers and the development of root systems. Phosphorus availability is especially critical in young seedlings and mature, flowering plants. Sinsemilla cultivators are familiar with phosphorus because it is a constituent of flower-booster fertilizers.

Potassium also affects metabolic functions by enhancing the formation of starches, sugars and oils. As these substances form the membranes of cells, potassium is a critical nutrient for maintaining strength. Cultivators use potassium in

62

flower-booster fertilizers and also as a periodic amendment to insure the plants' ability to stand up to wind, rain, frost and disease.

Minerals required in lesser amounts are called "secondary macronutrients." These minerals are calcium, which is an important constituent of cell walls; magnesium, a constituent of chlorophyll; and sulphur, which promotes beneficial soil bacteria and aids in the production of proteins. While calcium sources such as lime are used in correcting the pH of acidic soil, these secondary macronutrients are seldom used as fertilizers.

*Micronutrients:* There are seven micronutrients required for plant growth. These elements are boron, copper, iron, manganese, zinc, molybdenum and chlorine. Because these elements are used in such minute amounts, little is actually known about their role in growth. Until very recently, these elements were ignored in the nutrient systems of commercial agriculture. However, intensive watering has caused many of these micronutrients to leach from the soil. Plants exhibit this micronutrient deficiency in diminished productivity. For that reason, sinsemilla cultivators insure the availability of micronutrients within their nutrient systems.

For soil nutrients to be of use to plants, they must be in an available form. When water enters the soil, nutrients are picked-up in solution and are passed through the root xylems to the food-processing factories in leaves. The actual exchange of nutrients from soil to roots involves the movement of mineral ions. Nutrients, therefore, must be in an ionic form to complete the passage from soil to roots.

Soil nutrients become available through the biological processes in the soil. Through the metabolic activity of microbacteria, decaying organic matter is converted into inorganic minerals in an ionic form. Soil processes are governed by the amount of organic material, pH and temperature. When these controlling factors are out of balance, soil processes are adversely affected, and nutrients remain locked in the soil—unavailable.

# Nutrient Systems

As previously mentioned, cannabis is an energy-efficient plant capable of rapid growth. To realize this rate of growth, all of the mineral nutrients must be present in sufficient and available supply. To fulfill this requirement, sinsemilla cultivators establish nutrient systems. These systems enable cultivators to control nutrients in such a manner so as to increase productivity.

Nutrient systems are extremely important in the cultivation scheme of sinsemilla because of the leaching action of continued watering. Because of the value society places on sinsemilla, cultivators are likely to water their cannabis plants

63

more frequently than they would their zuchinni plants. In controlled soil mediums (like those confined in vessels), continual watering rapidly leaches nutrients from the soil. Nutrients leached from soil, or consumed by plants, must be replaced. For that reason, nutrient systems are established when the plant is young and continued until the plant is harvested.

*Organic Nutrient Systems:* Systems which rely on soil processes to provide mineral nutrients are called "organic" systems. These systems depend on the soil decomposers—microbacteria and worms—to process decomposing organic matter into the inorganic mineral nutrients required for autotrophic metabolism

Through the colloquial talk of the streets, the term "organic" has become synonomous with laid-back country folk who let nature take its course in mellow vegetable gardens. But in the case of sinsemilla cultivators, "organic" has

Figure 19

## AVERAGE ANALYSIS OF MINERAL CONTENT IN ORGANIC MATERIALS

## Nitrogen = N;  Phosphoric Acid = P;  Potassium Oxide = K

| | % N | % P | % K | | % N | % P | % K |
|---|---|---|---|---|---|---|---|
| Dried Blood Meal .... | 13.00 | 1.50 | — | Seaweed (kelp) ....... | .20 | .10 | .60 |
| Fish Meal ........... | 10.40 | 5.90 | — | Alfalfa Hay .......... | 2.50 | .50 | 2.10 |
| Digested Sewage | | | | Alfalfa Straw ........ | 1.50 | .30 | 1.50 |
| Sludge ........... | 2.00 | 3.01 | — | Bean Straw .......... | 1.20 | .25 | 1.25 |
| Activated | | | | Grain Straw ......... | .60 | .20 | 1.10 |
| Sewage Sludge .... | 6.50 | 3.40 | .30 | Cotton Gin Trash .... | .73 | .18 | 1.19 |
| Tankage ............. | 7.00 | 8.60 | 1.50 | Cotton Seed ......... | 3.15 | 1.25 | 1.15 |
| Cotton Seed Meal .... | 6.50 | 3.00 | 1.50 | Winery Pomace ...... | 1.50 | 1.50 | .75 |
| Bone Meal (steamed) . | 13.00 | 15.00 | 13.00 | Olive Pomace ........ | 1.20 | .80 | .50 |
| Bone Meal (burned) .. | — | 34.70 | — | Apple Leaves ........ | 1.00 | .15 | .35 |
| Castor Pumic ........ | 6.00 | 3.00 | .50 | Oak Leaves .......... | .80 | .35 | .15 |
| Green Sand ......... | — | 1.50 | 5.00 | Peach Leaves ........ | .90 | .15 | .60 |
| Hoof and Horn Meal .. | 12.50 | 1.75 | — | Raspberry Leaves .... | 1.35 | .27 | .63 |
| Incinerator Ash ...... | .24 | 5.15 | 2.33 | Corn Stalks .......... | .75 | .40 | .90 |
| Wood Ash .......... | — | 1.50 | 7.00 | Tobacco Stems ...... | 2.00 | — | 7.00 |
| Molasses (residue) ... | .70 | — | 5.32 | Red Clover .......... | .55 | .13 | .50 |
| | | | | Immature Grass ...... | 1.00 | .50 | 1.20 |
| Manures: | | | | Brewer's Grain (wet) .. | .90 | .50 | .05 |
| Bat Guano .......... | 13.00 | 5.00 | 2.00 | Cocoa Shell Dust .... | 1.04 | 1.49 | 2.79 |
| Goat Manure ........ | 2.77 | 1.78 | 2.88 | Coffee Grounds (dry) . | 1.99 | .36 | .67 |
| Dairy Manure ........ | .70 | .30 | .65 | King Crab (dry) ...... | 10.00 | .26 | .06 |
| Steer Manure ........ | 2.00 | .54 | 1.92 | Lobster Shells ....... | 4.60 | 3.52 | — |
| Horse Manure ....... | .70 | .34 | .52 | | | | |
| Hog Manure ......... | 1.00 | .75 | .85 | | | | |
| Sheep Manure ....... | 2.00 | 1.00 | 2.50 | | | | |
| Rabbit Manure ....... | 2.00 | 1.33 | 1.20 | | | | |
| Duck Manure ........ | .60 | 1.40 | .50 | | | | |
| Poultry Droppings .... | 4.00 | 3.20 | 1.90 | | | | |
| Poultry Manure ...... | 1.60 | 1.25 | .90 | | | | |

NOTE: This source list reflects only average nutrient yields. Actual yields may vary.

# COMMON NUTRIENT DEFICIENCIES

| NUTRIENT | DEFICIENCY |
|---|---|
| **Nitrogen** | yellowing of lower leaves / end of leaves die back / yellowing proceeds to upper portion of plant / overall plant symptoms include slow, sparse growth |
| **Phosphorus** | dying leaf tips on lower portion of plant / yellowing from bottom growth to top / overall symptoms include stunted growth with dark, dull leaves |
| **Potassium** | dying leaf tips on lower portion of plant / older leaves curl and show dead spots / overall symptoms include plant rusts and mildews |
| **Calcium** | immobile younger leaves / curling and crinkled leaf edges / overall symptoms include underdeveloped roots and stunted growth |
| **Magnesium** | gradual increase in purple colored leaves and stems / leaf veins remain green while rest of leaf yellows and dries / overall plant symptoms include stunted growth and lackluster flowering |
| **Iron** | yellowing at the tips of new growth then spreading inward / yellow areas become dry and scorched / overall plant health may be good as iron deficiency occurs in new growth |

Figure 20

become synonomous with high-performance plant growth. Rather than allowing nature to control the availability of nutrients, sinsemilla cultivators fine-tune those environmental elements—temperature, pH, etc.—that affect nutrient availability, thereby increasing the growth rate of plants.

To insure that organic systems provide enough nutrients, cultivators continually add more organic substances to the top layer of the soil medium (see figure #19). Some of these substances, like blood meal, are used to provide more nutrients; while others, like kelp, are used to increase the activity of decomposers.

Organic nutrient systems, when properly managed, provide several important benefits in the production scheme of cannabis. First, these systems provide balanced diets of the 13 soil nutrients essential to growth. This diet encourages a healthy and vigorous metabolism, enabling cannabis plants to survive in the unfamiliar climates of northern latitudes. Second, they improve those aspects of the finished product—bouquet, taste, appearance—which constitute quality. And Third, organic nutrient systems increase in value with the passage of time. Like plants, these systems are alive and growing. With their growth additional nutrients become available, hence an increase in value to cultivators.

The disadvantage of organic nutrient systems for cultivators is the initial investment in the time it takes to establish a living soil.

*Chemical Nutrient Systems:* Systems which rely on mineral salt fertilizers to provide plants with nutrients are often referred to as "chemical systems." Basically, chemical nutrients are elements from the environment which have been chemically treated to increase their availability to plants.

To insure adequate supplies of nutrients, cultivators merely apply periodic doses of mineral salt fertilizers to the plants and soil. By continually monitoring growth for signs of deficiencies (see figure #20), cultivators can apply more fertilizer as needed, thereby insuring optimum growth rates and productivity.

The advantage of chemical nutrient systems for cultivators is in the availability of chemical fertilizers through numerous local retail outlets. In addition, these mineral salts provide immediately available nutrients to the plants.

The principal disadvantage in using chemical systems is in the difficulty of providing plants with balanced diets. Commercial chemical fertilizers are composed primarily of nitrogen, phosphorus and potassium. While these fertilizers encourage rapid growth, they adversely affect soil processes by leaving behind toxic mineral salts in the soil. This build-up of salts diminishes the activity of soil processes which make available other essential soil nutrients. Without balanced diets, plants are less able to withstand the environmental stresses inherent in unfamiliar environments.

In addition, with chemical systems there is always the possibility of killing plants through applications of toxic overdoses. Sinsemilla cultivators are especially prone to this danger because of their desire to produce more flowers. Finally, constant applications of mineral salts diminish the taste and bouquet of sinsemilla flowers. As sinsemilla cultivators consider quality an aspect of productivity, continued use of these mineral salts becomes an important consideration.

*Combined Nutrient Systems:* Often cultivators combine organic nutrient systems with occasional applications of chemical fertilizers. If properly managed, these combined nutrient systems can provide a well-balanced diet of essential nutrients from organically-rich soil as well as an occasional boost from the immediately available chemicals.

## Applying Nutrients

There are several techniques used in applying additional nutrients to plants. The following is a brief description of these fertilizer application techniques.

*Topsoil Dressings:* In organic soil systems, soil amendments (see figure # 19) are often mixed with the top layer of the soil medium. Through the actions of decomposers and watering, these minerals become available and are leached

down into the root system.

*Solutions:* Soluble fertilizers (organic or chemical) are mixed in solution with water and applied to the topsoil. These solutions are especially convenient in large microclimate systems, as the plants can be fed and watered at the same time. Popular extracts for solutions include fish and kelp emulsions.

*Foliar Feeding:* Plants have the ability to absorb water and nutrients through their leaves. Soluble fertilizers—both organic and chemical—are often diluted in water and sprayed in a fine mist upon the leaves. Foliar feeding is beneficial to plants suffering from root stress or nutrient deficiencies.

All of these techniques for applying additional nutrients, of course, are predicated upon a good deal of sensitivity upon the part of the cultivator. Without this attention to detail, plants will suffer and productivity will diminish.

The sinsemilla technique is predicated upon the control of those environmental elements which affect the growth of photosynthetic plants. To obtain this control, cultivators establish systems for the management of light heat, water, soil and nutrients. When all of these elements are present in sufficient and available supply, plants are enabled to realize their maximum rate of growth. The greater the rate at which these cannabis plants grow, the more elements from the environment they will process. When plants are harvested at the end of the cultivation cycle, the light, heat, water, soil and nutrients so judiciously managed are returned to cultivators in the form of sinsemilla flowers.

# Chapter 5

# Microclimates

To establish microclimate systems, elements needed for plant growth must be incorporated into garden locations. As Prohibition has restricted these garden locations to small spaces environmentally and climatically unique to the surrounding areas, we call them microclimates.

The environmental characteristics of microclimates are extremely important factors in determining the outcome of sinsemilla cultivation. These characteristics determine, for example, how many plants can be safely cultivated, what kinds of additional provisions must be made for security and which kinds of adversities must be overcome. The selection of microclimates, consequently, is one of the most important decisions cultivators make.

While microclimates are, by definition, unique to individual situations, I have endeavored to construct a classification system through which they can be described. In this construction, microclimates are divided into three possibilities: outdoors, indoors and greenhouses. Through a basic description of each of these possibilities, one can reach an understanding of how sinsemilla cultivators select locations and how, as microclimate systems, those locations are used to overcome the adversities of a hostile world.

# OUTDOOR MICROCLIMATES

Outdoor microclimates are based on coordinating the interaction of growing plants with native environments. After this has been accomplished, the intensity of this interaction is amplified by regulating those elements which affect the growth and productivity of plants. In this respect, outdoor microclimates provide a context in which sinsemilla cultivators cooperate with native environments in the production of cannabis flowers.

Before outdoor microclimates can be utilized for cultivation, they must fulfill two important requirements. First, all of the elements necessary for growth must be present in sufficient and available supply. This requirement limits the selection of outdoor microclimates to those areas that can provide essential elements like water and sunshine. Second, outdoor microclimates must have sufficient cover to conceal growth. Without this protective cover, outdoor microclimates are vulnerable to any number of disasters, not the least of which are Marijuana Eradication Teams and thieves.

The basic requirements for selecting microclimates, therefore, are the presence of elements needed for growth and protective cover. In addition, there are other considerations which affect the selection of outdoor microclimates. As these considerations vary with location and intent, I will discuss them in general terms.

## Moderating Influences of Outdoor Microclimates

Ounce for ounce, sinsemilla flowers are among the most expensive products in the world to purchase. Because of this value, individuals often see cultivation as an easy way of getting rich—of becoming a "sinsemillionaire." A few exceptions notwithstanding, most individuals find this logic flawed by the end of the cultivation cycle.

Sinsemilla cultivation has certain built-in mechanisms which control the size of outdoor microclimates. Both elements necessary for growth and the availability of cover affect the size of potential outdoor locations. In addition, labor plays a very important role in restricting the number of plants which can be efficiently cultivated within outdoor microclimates.

*Labor:* Sinsemilla cultivation is a labor-intensive occupation. To control a microclimate system, cultivators must be present to control and regulate those elements which affect growth and productivity of plants. An individual can exercise this control over a limited number of plants. When this limit is exceeded, the individual loses this control and the growth of plants is adversely affected.

69

Figure 21:
*CANNABIS SATIVA* IN
SOUTH-FACING SLOPE

As a result, large numbers of plants require the presence of large numbers of individuals. The more individuals required to maintain a microclimate system, the more shares must be divided when the crop is harvested. In addition, large numbers of individuals must be fed, clothed, and otherwise provided with the basic amenities of day to day living.

The most difficult aspect of controlling a large labor force, however, is simply keeping the laborers out of trouble. As the cultivation cycle is extended over a period of roughly six months, personal disagreements can build up into monumental confrontations. In addition, the more people who know about a microclimate location, the harder it is to keep secret.

Because of the diminishing returns characteristic of larger outdoor microclimates, sinsemilla cultivation has never become popular with organized crime. There is simply too much work involved. Organized crime relies on somebody else's labor to produce cheap goods which can be sold for exorbitant prices.

70

Rather than being paid cheap wages, sinsemilla cultivators are more likely to go out and establish their own microclimate systems.

Still, the temptation to grow big is profound. In a conversation with a deputy sheriff, I learned of an expression used in describing these big deals. "Yeah, we call those big gardens 'Lost Dutchmans' after the legendary mine. Finding a Lost Dutchman is something we dream about. As a matter of fact, we've got one going right now with about 2500 plants. For this bust we're gonna use helicopters and swat teams."

Through these mitigating factors of microclimate size, a generalization can be made concerning location. Large commercial gardens, like the one in figure #21, are restricted to rural areas with mountainous, tree-covered terrain. Cities, of course, restrict the capacity of gardens to a few plants like those in figures #23 and 24. Small, personal-sized commercial gardens, like the one integrated into the underbrush in figure #22, can be located in a variety of locations.

Figure 22: *CANNABIS INDICA* WITH GROUND COVER

*Security:* Sinsemilla cultivation activity can be—and is—detected by being seen, heard and smelled. Once this activity has been detected by those unfriendly to the cultivators, there is little the latter can do but harvest and run. Consequently, the security of an outdoor microclimate is predicated on not being detected.

To cultivate cannabis without being detected requires the skillful use of camouflage. Cultivators must disguise the growth of plants within a location, the location within the surrounding area, and the purpose of their labor. To affect this disguise, cultivators employ just about anything from surplus camouflage netting to cans of flat black spray paint.

While filming a garden in Northern California, I watched as two partners experimented with materials to disguise the paths which lead to and from the garden. The first substance used was straw from a nearby farm. But when this

Figure 23:
*CANNABIS SATIVA* IN
BACKYARD ENVIRONMENT

Figure 24:
DWARFED HYBRID—
DECK ENVIRONMENT

straw was scattered across the dusty trails, it reflected a brilliant gold color uncharacteristic of the surrounding terrain. The next material tried was a couple of bales of "grass hay." This substance, when spread over the trail, closely matched the dull brown of the native grasses, and therefore was most effective in camouflaging the garden's location from the Eye-in-the-Sky.

In areas of higher population density, noise is an important consideration. I visited a group of cultivators in one of the more populated areas of the Pacific Coastal Range. As they were wearing camouflage clothing, I could tell they were concerned about being seen; but as they were drilling away at the hillside with a two-man auger, they were not so concerned about being heard by the neighbors who lived a couple hundred yards downslope.

In city environments, smell is an important consideration. When plants are in florescence, they emit a rich, musky fragrance which is extremely distinctive. If

the prevailing airflow should carry this aroma across the backyard fence and into the neighbors' kitchen window, it will surely stimulate curiosity, to say the least.

*Environmental Adversities:* All outdoor microclimates are subject to certain environmental adversities which can affect the growth of plants. Deer, grasshoppers, rats and rabbits are but a few examples. These adversities, of course, vary from location to location. Through the selection of microclimates, cultivators limit the effectiveness of these adversities.

I visited one cultivator who concealed his plants in the tall grasses and berry bushes near a dormant volcano. In the spring, the tall green grasses provided an excellent camouflage for the young plants. Later in the summer, however, the dry grass provided a population of three-inch long locusts which used the cannabis plants for a source of moisture and food. His neighbor, on the other hand, has secreted his plants midst an area of poison oak and rocks. Late in the summer, the rocks and oak provided a screen which mitigated the effects of the thirsty hoppers.

Of the three possibilities for microclimates, the outdoor locations are characteristically the most intense. Elements from the natural environment, when present in sufficient and available supply, provide for the most productive growth. In the same respect, however, exposure to these elements provides for an intense vulnerability. When the elements needed for growth are not available, or when the vulnerability proves overwhelming, cultivators are likely to consider other microclimate possibilities.

# INDOOR MICROCLIMATE

Indoor microclimates are based on coordinating the interaction of growing plants with environments fabricated by cultivators. The intensity of this interaction is then amplified by the regulation of those elements which affect growth and productivity. In this respect, indoor microclimates are the cultivators' way of outwitting the hostilities of outdoor environments.

For indoor microclimates to be productive, two basic requirements must be fulfilled. First, the cultivator must select a suitable structure. Some important considerations in selecting these structures include the amount of available space, ventilation and drainage. Second, cultivators must provide all of those

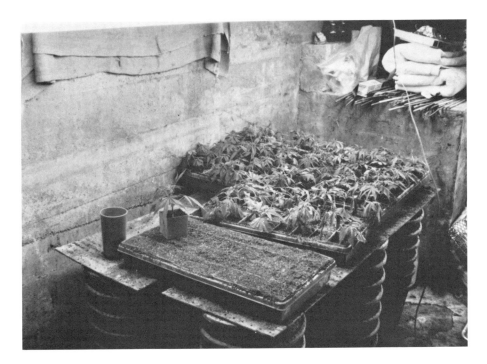

Figure 25: PROPAGATION OF FEMALE CUTTINGS

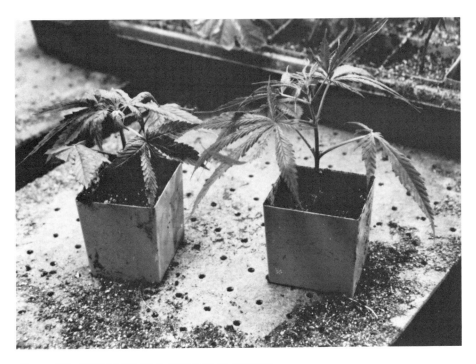

Figure 26: *INDICA/SATIVA* HYBRID CUTTING

75

elements for growth which nature would provide in the outdoors—light, heat, water, soil and nutrients. In addition, enclosed indoor microclimates are often deficient in the most basic of environmental elements—air. These ingredients of growth must then be incorporated in such a manner so as to be available to the plants.

The basic requirements for establishing indoor microclimates, therefore, are the availability of suitable structures and the ability of cultivators to fabricate environments within these structures that will enable plants to grow. In addition, there are other considerations which influence the selection of indoor microclimates. As with all microclimate considerations, these factors vary from location to location.

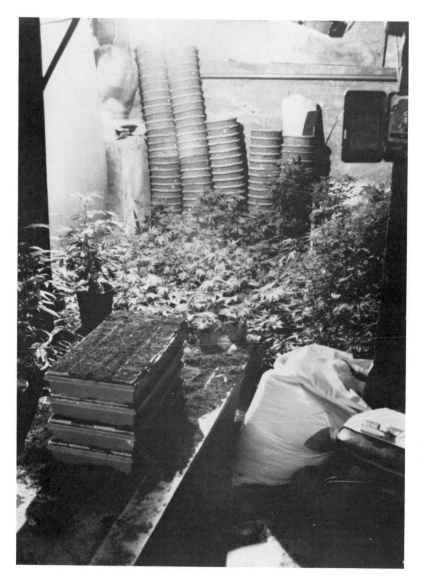

Figure 27:
"MOTHER"
PLANTS FOR
PROPAGATION
OF CUTTINGS

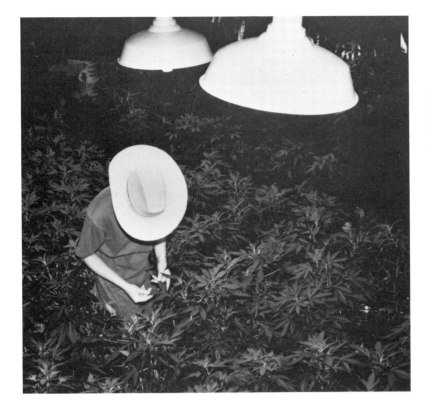

## Moderating Influences of Indoor Microclimates

Indoor microclimates provide cultivators with an attractive alternative to the vulnerability of growing illegal plants outdoors. Because this alternative is so attractive, individuals often consider it easy. There are, however, inherent difficulties in growing outdoor plants indoors, not the least of which is the constant supervision required to maintain a functioning microclimate system in a totally fabricated environment.

*Electricity:* Indoor microclimates are based on replacing the radiant energy from the sun with the radiant energy from lights. As the growth rate and productivity of growing plants are determined by the intensity and period of light, electricity is an extremely important factor in indoor cultivation.

The use of lights for cannabis cultivation was pioneered by growers in the Pacific Northwest. In that region of the country, rainfall provides an almost insurmountable adversity for outdoor cultivation. Yet this abundant rainfall, when harnessed by reservoirs, provides an inexpensive source of hydroelectric power. Quite naturally, cultivators in this section of the country began utilizing this energy source to run grow-lights.

The cost of electricity, therefore, is one of the mitigating factors in selecting an indoor microclimate. One individual I met recently exclaimed, "Man, did we ever score!! We found a small area near town that is on a rural electric cooperative. The rates there are about one-half of PG&E's."

*Lights:* A significant breakthrough in indoor cultivation occurred when cultivators began using 1000 watt metal halide lamps. These lights provide the light source for large sports arenas, because they closely approximate the light frequency of sunlight and therefore provide a balanced source of illumination for video cameras. Because of this light frequency and the intensity of 1000 watts, these metal halide lamps have significantly increased the productivity of indoor microclimates. (See color plate #9.) On the other hand, these lights are expensive to purchase and consume a lot of electricity.

*Environmental Adversities:* While indoor microclimates may escape the detection of the Eye-in-the-Sky, they are vulnerable to certain environmental adversities which are not prevalent in the outdoors. Among these adversities are insect infestations, diseases and mutations.

Outdoors, nature provides a balance in the life cycles of insect populations. For the insects which feed on growing plants, there are corresponding populations of predator insects. Among the many familiar predator insects are lady bugs, spiders, praying mantises and lacewings. Indoors, it is extremely difficult for a cultivator to match this natural balance. As a result, insect populations can quickly overwhelm the plants growing in a microclimate.

Because of the lack of balance indoors, cultivators are forced to maintain sanitary conditions inside their microclimates. Without this cleanliness, decaying plant matter on the floor will quickly spawn overwhelming populations of pests like the spider mite. Once this happens, cultivators are forced to rely on chemical pesticides, thereby adversely affecting the quality of sinsemilla flowers.

These environmental balances are also critical factors in controlling the spread of diseases. Many indoor microclimates have air saturated with the water transpired from the growing plants. Some of the cannabis strains—like the *indica* varietals from Afghanistan—have genotypes keyed to growth in hot, dry air. As a result of this relationship between wet air and dry plants, one often sees a condition the cultivators call "bud rot." This condition is manifested in the molding of plant parts—stems, leaves and flowers—and is spread by microscopic spores. If the microclimate is not sanitary, this bud rot quickly spreads to other plants.

Sometimes the adversities of an unfamiliar and hostile environment stimulate mutations in cannabis plants. One example of this effect occurred in some Afghani *indica* plants cultivated under lights. These particular plants developed growth which resembled the common cauliflower. To the cultivators, this mutation became known as "that damned cauliflower."

While factors mitigate the size of indoor microclimates, cultivators have the

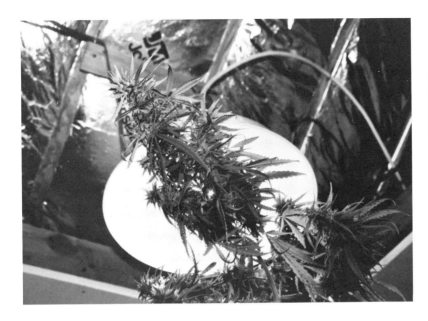

Figure 29:
*SATIVA/INDICA*
HYBRID UNDER
METAL HALIDE
LAMP

Figure 30: FLORESCENT *SATIVA* UNDER METAL HALIDE LAMPS

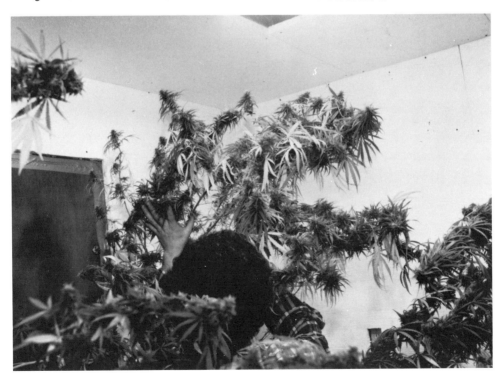

opportunity to compensate through their total control of the microclimate's environment. By controlling the photoperiod, for example, cultivators are able to control the plants' cycle of growth at will. As a result, indoor cultivators have fine-tuned their ability to first determine the sex of cannabis plants, then make cuttings of those females deemed suitable for producing flowers. In figures #25, 26 and 27, one can see an example of this cutting operation.

In growing only female cuttings, indoor cultivators increase the productivity of their limited space significantly by growing only the most productive part of the female plants—the flowering branch ends. In addition, because indoor microclimates do not rely on the natural seasons of the sun, the cultivation cycle can be controlled in such a manner so as to produce three to four crops per year.

Multiple crops are accomplished by having one section of the microclimate devoted to propagating cuttings (figures #25, 26), another section devoted to vegetative growth and, finally, a section devoted to the flowering cycle. (See color plate #9).

Another way indoor cultivators take advantage of their control is by propagating female cuttings and then preparing them for growth in outdoor environments (see figure #28). By doing so, they are providing a service not unlike that of wholesale nurseries in the more legitimate industries of horticulture. Outdoor cultivators find these cuttings services extremely valuable. Female cuttings eliminate the risk of unproductive male plants. In addition, as these cuttings are generally three months old, "in the ground" time is reduced significantly.

The advantages of indoor microclimate systems, therefore, are twofold: 1) Cultivators avoid adversities in the environment like bad weather and low-flying airplanes. 2) Cultivators control environments to such an extent that they are able to increase the efficiency of production.

# GREENHOUSE MICROCLIMATES

Greenhouse environments are based on coordinating the interaction of growing plants with elements from nature, confined to a fabricated environment. The intensity of this interaction is then amplified by regulating those elements which affect the growth and productivity of plants. In this respect, greenhouse environments are hybrid combinations of outdoor and indoor microclimates. As such, they are studies in compromise.

Before greenhouse microclimates can be utilized for cultivation, they must

1    Seed Bank

2    Color-Coded

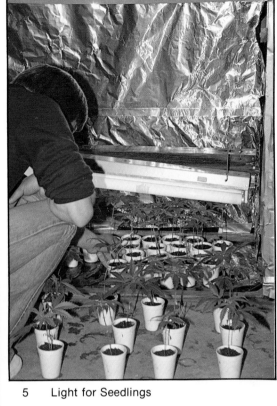

5    Light for Seedlings

3    Companion Planting

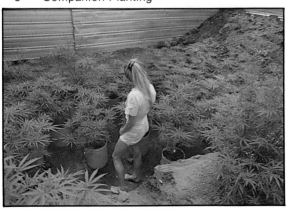

4    Hole Garden

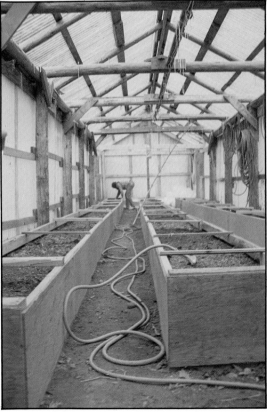

6    Greenhouse in Winter

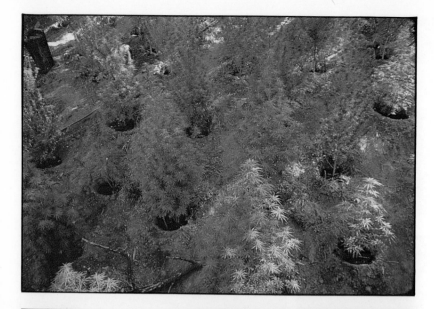

7     Verdant Slope

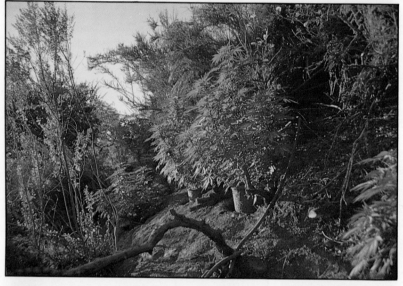

8     Vessels in Slope

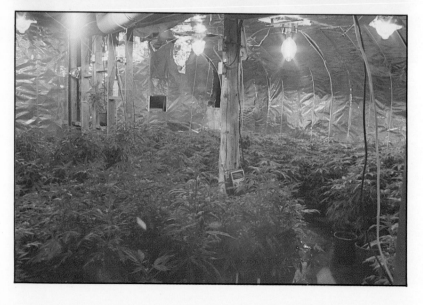

9     Production Lightroom

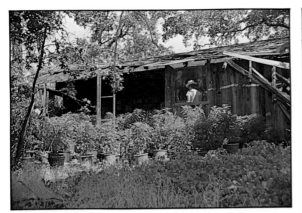

10    Old Barn Farm

11    Secret Garden

12    Green Growth

13    Florescence

14    Field Test

15    Garden Shoot

16    Garden Sentry

17    Dwarf Cuttings in Chaparral

18    Kodachrome Garden

19    Infrared Garden

20    Garden Entrance

21    Plants, Vessels and Slope

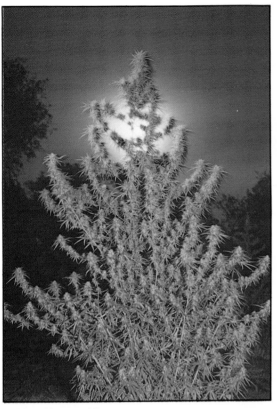

22    Harvest Moon

23    Cannabis Sativa

24    Aerial Perspective

25    Garden Perspective

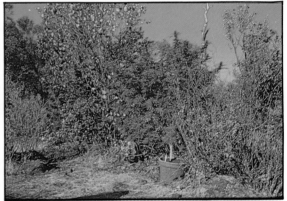

26    Kodachrome Plant

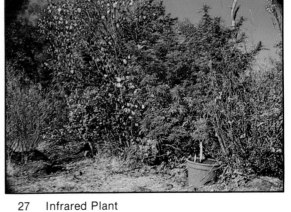

27    Infrared Plant

28 Night Watch

29 Harvest Rain

30 Garden and Shelter

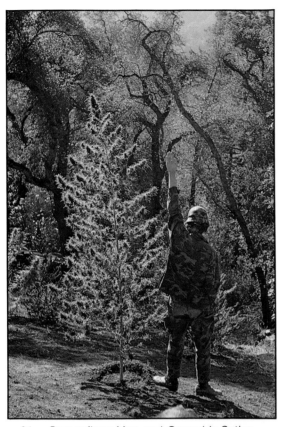

31    Camouflage Man and Cannabis Sativa

33    Cannabis Indica and Cannabis Sativa

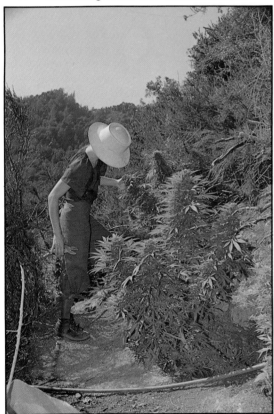

32    Selective Harvest

34    Out-of-the-Ground

35 Varietals

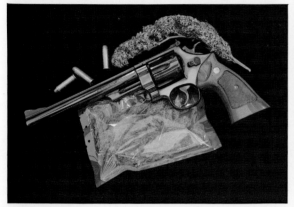

36 Stash

37 Thanksgiving

38 Katydid

39 Indica Flower

40 Sativa Flower

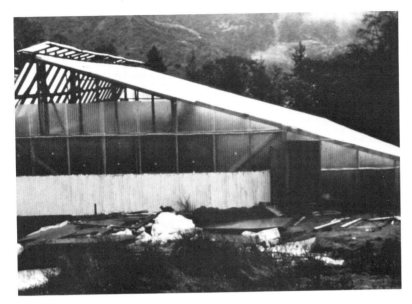

Figure 31:
COMMERCIAL-
SCALE GREEN-
HOUSE (photo
by California
Attorney
General's
Office)

Figure 32:
"A" FRAME
GREENHOUSE
(photo by Cali-
fornia Attorney
General's Office)

fulfill two requirements. First, the elements from nature required for growth must be present in sufficient and available supply. Second, the architectural design and physical orientation of the structure must take maximum advantage of these elements from nature.

89

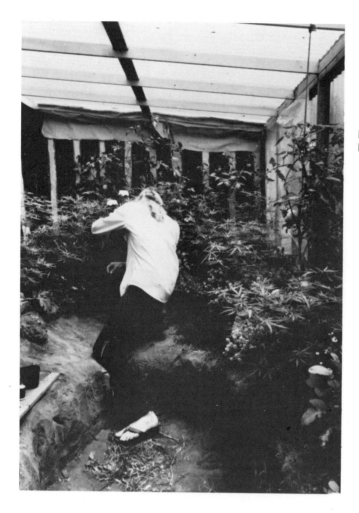

Figure 33:
BACKYARD GREENHOUSE

The design of greenhouse environments is important in that it enables cultivators to better control those elements of nature which affect growth. A good design, for example, enables one to increase light intensity, regulate the circulation of air and modify temperature extremes. The physical orientation of a greenhouse, in a similar respect, enables one to take better advantage of those elements present in the natural environment. A structure oriented towards the south, for example, increases the availability of light during the spring and autumn.

When these requirements have been fulfilled, the greenhouse microclimates are productive environments for the growth of plants. Quite naturally, sinsemilla cultivators have become among the first to recognize this potential.

# Moderating Influences of Greenhouse Microclimates

As with all microclimates, greenhouse environments have certain mitigating influences which affect their use for the cultivation of sinsemilla. These factors, of course, vary from situation to situation.

*Appearance:* In many respects, greenhouse environments share the same vulnerability as do the outdoor microclimates. A large greenhouse out in the middle of nowhere, for example, stimulates curiousity: "I wonder what's going on in there?" While the greenhouses featured in figures #31 and 32 provided ideal environments for cultivation in the hills of Mendocino County, they also attracted the attention of the Eye-in-the-Sky. As a result, these photographs were taken by representatives of the California Attorney General's office. This vulnerability is common to all greenhouse structures, be they in the hills of the countryside or in somebody's backyard in the neighborhoods.

To compensate, cultivators often employ camouflage in the design of their structures. In Southern Oregon, for example, one ingenious individual camouflaged his large greenhouse by making it look like the rest of the buildings on his property. These other buildings all had rolled-tin roofing. By using an opaque fiberglass roof on his greenhouse, the structure was made to appear similar to the rest of the buildings from above. As a result, the Eye-in-the-Sky flew right on by.

*Environmental Adversities:* As with indoor microclimates, greenhouses-grown plants are vulnerable to insect pests and diseases. Cultivators must compensate for this vulnerability by maintaining sanitary conditions and introducing populations of predators like lady bugs and praying mantises. Without these measures, cultivators must resort to ever-increasing doses of chemical pesticides, thereby reducing the quality of their sinsemilla flowers.

Greenhouse microclimates combine the control inherent in fabricated environments with the intensity inherent in natural elements. On the other hand, they also diminish, to some extent, access to these elements and the control over them. In this respect, greenhouse microclimates are studies in compromise.

As the selection of microclimates is so fundamental to the productivity of growing plants, sinsemilla cultivators become extremely sensitive when making their selection. Some microclimates are simply better than others. In a "surfer's slum" in San Diego, I ran across a good example of this value. In one large home lived four young surfers. Each of these surfers had his own bedroom. While three of these bedrooms were in all respects normal, one was exceptional. It had a padlock on the door and was posted, "NO TRESSPASSING."

Just outside of this bedroom's window was the perfect microclimate for six or seven cannabis plants. Because of this little microclimate, the bedroom had a value all its own. As a result, the bedroom's occupant had an uncharacteristic stability in his life. He had lived in this bedroom for a long time and had become

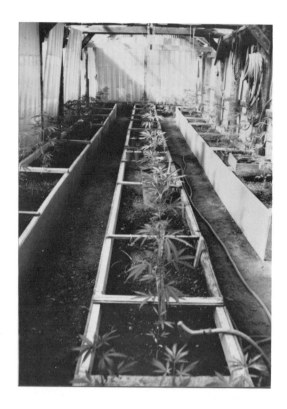

Figure 34: GREENHOUSE IN SPRING

Figure 35:
GREENHOUSE IN AUTUMN

92

Figure 36:
GREENHOUSE AT HARVEST

the ruling resident. To protect the value of his little piece of space, he made sure the other residents behaved themselves.

In many respects, this surfer's bedroom is a microcosm of every sinsemilla microclimate. Good locations have a value which transcends normal real estate appraisals. Real estate agents, of course, were quick to note this value. One now finds newspaper ads which read something like this: "For Sale: perfect 10 acres of south-facing slope with water/ remote and covered with trees/ perfect for family gardening."

By integrating the elements needed for plant growth into these microclimates, cultivators fashion for themselves microclimate systems. These systems give them control over the growth of cannabis plants to an extent unmatched in horticultural history. In exercising this control, cultivators become environmental technicians; and because their product is so valuable, they develop a soberness of character one would expect to find in such highly-skilled individuals.

# Part Four

# The Cultivation Cycle

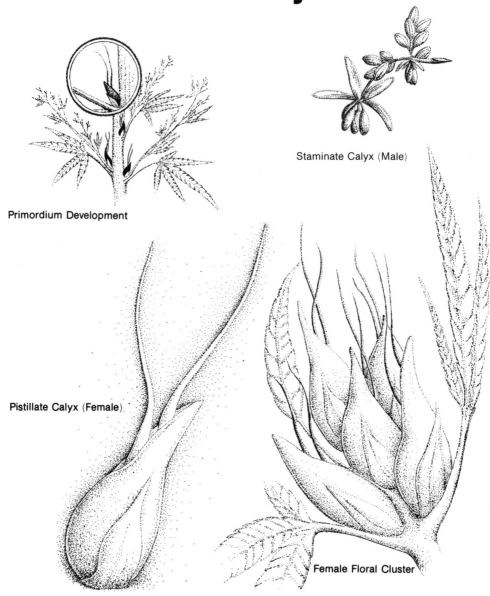

Primordium Development

Staminate Calyx (Male)

Pistillate Calyx (Female)

Female Floral Cluster

Figure 37: CANNABIS REPRODUCTIVE GROWTH

94

# The Cultivation Cycle

Cannabis is an autotrophic organism capable of sustaining life through its photosynthetic metabolism. In other words, cannabis does not rely on the benevolence of human beings to get by in the world. On the contrary, the genus has a weed-like character that has sustained it through eons of environmental adversities. This weed-like character is manifested in fast growing stems and roots, rapid leaf development and prolific reproductive systems.

However, cannabis has other attributes which have resulted in its longstanding relationship with human beings. Because of its fibrous stem and the presence of the chemical THC, people began domesticating this plant species thousands of years ago. Said Herodotus, in the 5th Century B.C., "The Scythians take some of this hemp-seed, and creeping under the felt coverings, throw it upon the red-hot stones; immediately it smokes, and gives out such vapour as no Grecian vapour-bath can exceed; the Scyths, delighted, shout for joy. ..." This relationship is symbiotic: Plants are provided with the elements needed for growth and people are provided with fiber and THC.

In the beginning, cultivation consisted of supplying plants with water, then selecting the fittest survivors to provide seed for the next crop. In the past several decades, however, people have learned more about husbanding plants than all of the knowledge gained through the previous millennia combined.

Today's techniques enable cultivators to direct the cycle of growth in a technically precise manner. Given a small portion of leaf from a "mother" plant, for example, it is now possible to create a whole field of clonal replicas which will, in every respect, resemble that "mother" plant. Because cannabis is so highly valued, cultivators tend to use those techniques which enable them to direct growth. This section of *The Sinsemilla Technique* is about those methods; for that reason, I have entitled it "The Cultivation Cycle."

To understand how these methods are employed, it will first be necessary to understand the natural growth cycle of cannabis. Cannabis is an annual whose life cycle is determined by the interaction of genetic heritage with physical characteristics in the environment. Because genetic heritage differs from varietal to varietal, this life-cycle description is general in nature.

*Spring:* For annual plants, spring is the catalyst for germination. An increasing photoperiod, escalating temperatures and water cause dormant seed embryos to explode into life. From these germinated seeds, roots appear and, guided by the forces of gravity, become anchored in the earth; sprouts are then lifted skyward by the multiplying cells in the new stem and leaves appear. With these embryonic leaves, plants are capable of sustaining life by processing elements from the surrounding environment.

In a short period of time, regular leaves appear in stages. At first, the leaves have only a single blade ... then three blades ... then seven. The roots expand and the stem shoots skyward in competition for sunlight with surrounding plants. This competition for elements is the driving force of the vegetative (or green-growth) cycle of the plants' development.

*Summer:* As the intensity of environmental elements increases with the coming of the summer solstice, plants enter their most vigorous phase of vegetative growth. With each new leaf, the plants' ability to produce more leaves escalates. The roots grow deeper and the stems grow taller in competition for elements. After the solstice, growth becomes characteristically more elaborate and dense. Seven-bladed leaves give way to five-bladed leaves; opposing branches give way to alternating branches.

*Autumn:* With the advent of the autumnal equinox, light-sensitive hormones within the plant signal a change in life-cycle. Plants respond by initiating reproductive growth—flowers. To synthesize this reproductive growth, plants store the scarce elements of water, nutrients and minerals. As a result, overall vegetative growth slows significantly.

Cannabis is dioecious; that is, staminate (male) flowers are on one individual plant while pistillate (female) flowers are on another. (True to the weed-like character of cannabis, however, certain environmental adversities often cause sex reversal, or monoecious development in which both staminate and pistillate organs appear on the same plant.)

Male plants respond to the diminishing photoperiod approximately one month before the females. Small staminate flowers (see figure #37) appear at the intersection of small branch nodes behind small leaf spurs. Gradually, these staminate flowers appear at the branch ends in large loose clusters. Male plants mature earlier than do the females so that they have the ability to release large clouds of pollen on the emerging pistillate flowers of the female plants.

Female flowers first appear as two white or off-white fuzzy hairs which grow out of an embryonic seed pod. As with the male flowers, female "indicators"

96

emerge at the intersection of the main stem and branch nodes behind protective leaf spurs. Later, this flowering develops into tight clusters at the branch ends. Female flowering develops until the pistils have been pollinated by clouds of pollen carried on the wind from male plants. After pollination, each fertilized female flower develops a single seed.

*Winter:* After the autumnal equinox, the period of light diminishes rapidly towards the winter solstice and the plants begin their senescent cycle of growth. While seeds are developing within the female calyx, plants begin dying back. All of the minerals and nutrients flow from the leaves to the seeds. Chlorophyll begins decomposing and accessory colors, formerly hidden by the chlorophyll-green, appear. When mature, the seeds fall to the ground to await the coming of spring.

The life cycle of cannabis is fixed by its genetic heritage. By redirecting this fixed response, cultivators control the plants' cycle of growth so as to increase productivity and improve quality. The basic direction provided in sinsemilla cultivation, of course, is the direction of the plants' reproductive cycle. However, as Prohibition has forced cultivators to become more clever, this control has expanded. Today, sinsemilla cultivators direct every aspect of growth from the germination of seeds in the spring to the harvest of mature females in the autumn.

# Chapter 6

# Starts

Cultivation karma is simple: You reap what you sow. To insure that what is sown in the spring is worth reaping in the autumn, sinsemilla cultivators select and use only cannabis from the finest genotypes.

Within each seed is the native intelligence which enables the living plant to respond to a particular environment and produce a specific product. This intelligence is called genotype. The detectable expression in the living plant of the interaction between genotype and environment is called phenotype.

Genotypes, it is thought, evolve in response to two conditions: location and intent. After many generations of growth in a specific location, genetic intelligence evolves to cope with the environmental particulars of that location. These particulars include photoperiod changes, pests, availability of water, soil conditions and weather. In addition, many generations of being selected for specific characteristics—like THC content—also play a significant role in forming genetic intelligence.

Genotypes are controlled by genes which are passed along from one generation to the next. These genes occur in pairs, one from the gamete of the staminate plant and one from the gamete of the pistillate plant. When these genes differ in their effect upon phenotypic response, the plant is called a hybrid. Alterations in phenotypic response are created when one gene dominates another. These altered states then appear in succeeding generations.

The genetic intelligence inherent in every seed determines many phenotypic responses in the living plant. Among these responses are the rate of maturation, physical appearance, taste, bouquet and chemical constitution (or potency). For sinsemilla cultivators, genetic intelligence is the key to the economic bottom line

because it affects both productivity and quality. Security considerations notwithstanding, the selection of genotypes is the single most important decision cultivators make during the course of a cultivation cycle.

# CANNABIS GENOTYPES

All cannabis plants contain chemicals known as cannabinoids. To date, more than several dozen different cannabinoids have been isolated in this species of plant. To keep matters simple, I will limit this discussion to two of these cannabinoids, Delta 9 Tetrahydrocannabinol (THC) and Cannabinol (CBD).

The relationship of these chemicals in living cannabis plants is significant for cultivators and consumers alike. THC is the cannabinoid which produces the characteristic high of cannabis. CBD, on the other hand, limits the effectiveness of THC. When a cannabis varietal is high in THC and low in CBD, it is considered to be of good quality by those who consume cannabis for the high. When a varietal is high in CBD and low in THC, it is considered to be of low quality. The percentage of these chemicals found in any given plant is determined by the plant's genotype.

There are two classification systems used in categorizing the phenotypes of cannabis. The most common system is the distinction between *Cannabis indica* and *Cannabis sativa.* Over the centuries, cannabis cultivated for its THC content became known as *indica.* This designation, perhaps, was made in deference to the habits of those Moslem and Hindu civilizations of the Middle East. Cannabis cultivated for its fiber content became known as *sativa.* As mentioned, hemp fiber crops were one of the more important cash crops in early America.

This system is based on intent. The other classification system is based primarily on geographical location. It works something like this:

*Type 1:* Cannabis with high percentages of THC and low percentages of CBD falls within this class. These phenotypes are found, primarily, in areas south of the 30th meridian of latitude. Type 1 cannabis varietals are primarily of the "drug" type.

*Type 2:* Cannabis with intermediate ranges of THC and CBD falls into this class. These phenotypes are found in the geographical areas bordering the 30th meridian of latitude. Type 2 varietals are thought to have developed through the cross breeding of Types 1 and 3.

*Type 3:* Cannabis with high percentages of CBD and low percentages of THC falls into this class. These phenotypes are found in areas north of the 30th meridian of latitude. Type 3 varietals are primarily of the hemp-fiber type.

This classification system asserts that growing conditions of geographical

locations are the prime factor in determining the cannabinoid content of cannabis: Varietals from southern latitudes are likely to have higher concentrations of THC than those of northern latitudes.

In the preceding centuries, both of these classification systems were credible attempts at evaluating cannabinoid content. During this span of time, cultivation was a static endeavor: People in the southern latitudes cultivated cannabis for its THC content; and people in the northern latitudes cultivated cannabis for its hemp fiber production. At any rate, both location and intent seem to have a bearing on the chemical content—or chemotype—of cannabis.

With the advent of Prohibition, however, attempts at classifying chemotype became nebulous at best. In effect, Prohibition restricted cannabis cultivation to the varietals with high contents of THC. Varietals which possess the genetic intelligence to yield hemp fiber are not cultivated on a commercial basis anymore. (Some exceptions to this observation are found in China, Italy, Poland and Bulgaria.)

In the past several decades, the demand for phenotypes with high THC contents has resulted in a tremendous movement of seed strains throughout the world. Phenotypes from Africa, Columbia, Thailand and Nepal, for example, might be translocated to the hills of Mexico, where they are cultivated in large fields and then shipped into the United States. The resulting hybrid seeds then become the stock for domestic cultivation. This "stirring of the stew" has made it extremely difficult to categorize phenotypic phenomena.

Nevertheless, sinsemilla cultivators base their selection of genetic intelligence on these classification systems. Cannabis varietals are selected for their ability to yield high percentages of THC, and for their fixed response to specific environmental conditions.

The first concern of sinsemilla cultivators is in locating genetic intelligence capable of yielding cannabis with a high percentage of THC. Without this intelligence, cultivators might find themselves at the end of a cultivation cycle with a crop of flowers of no value.

One cultivator in the hills of Northern California experienced this misfortune in a varietal he called "California No-High." During the cultivation cycle, this strain appeared to be an excellent varietal—it grew rapidly, produced a high percentage of females, had a sweet bouquet and healthy appearance. When harvested, however, it simply did not yield a high, hence the name "No-High."

The percentage of THC is a function of genetic intelligence. To cultivate cannabis varietals high in THC, cultivators must select seeds from phenotypes high in THC. The most effective way cultivators have of making this selection is by simply testing the "mother" plant for the degree and type of its high.

In addition, phenotypic response to environmental conditions is of extreme importance to sinsemilla cultivators. The reason for this is simple: Whereas most of the high-THC content varietals come from areas below the 30th meridian of latitude, most of the United States is above this latitude. Most varietals, there-

fore, possess the genetic intelligence to grow in climates unlike that of the United States.

Perhaps the most profound example of this dilemma is in the use of Columbian seeds. Because of the tremendous amount of Columbian cannabis smuggled into this country by organized crime, there is a surplus of Columbian seeds. When cultivated, these seeds yield flowers high in THC. But as these seeds possess the genetic intelligence for growth in equatorial Columbia, the growing season is simply too short here in the United States. As a result, cultivators often find their flowering strains covered with snow.

On the other hand, phenotypes from Afghanistan are high in THC and come from the same latitude as Mendocino County. As a result, Afghani varietals are short-season plants. However, Afghanistan is a country of high, dry deserts, and Mendocino County is a country of low, coastal foothills. As a result, cultivators with Afghani varietals often find their plants molding away in the autumn rains which sweep in from the Pacific Ocean.

Phenotypic response to environmental conditions is an important consideration when selecting genetic intelligence. Cultivators often resolve this selection dilemma by using hybrid seed strains. For example, a cultivator in Mendocino might cross the rain-resistant characteristics of a Columbian varietal with the short-season characteristics of an Afghani varietal to produce a phenotype especially suited to the environmental conditions of Mendocino County.

# STARTS

In a natural setting, the life cycle of cannabis begins with spring. In cultivation, however, the life-cycle is likely to begin much earlier. By germinating seeds under lights, or by taking cuttings from mature female plants, cultivators extend their growing season significantly. These young plants are called "starts."

*Seed Starts:* Once cultivators have chosen a phenotype, they must select seeds from that phenotype for germination. There are two basic rules they seem to follow in making this selection: 1) Cultivators select healthy seeds. Healthy seeds are shiny and colorful on the outside, and fresh and full of life inside. In addition, cultivators prefer the largest seeds in the selection. 2) Cultivators select enough seeds. Enough is what is left after a cultivator's dog is overwhelmed by jealousy and wreaks havoc upon the young starts.

While techniques used in seed germination vary, they all approximate the ideal conditions in Adam and Eve's garden: The seed falls pointed-end up into the rich soil. It is then covered by a thin layer of humus. Seed and soil are kept warm by the diffused light of the sun and moist by intermittent rains (see figure #38).

To extend the duration of their cultivation cycle, cultivators germinate seeds indoors (see color plate #5). Because they are indoors, cultivators use a series of small vessels to contain the root growth of seed starts. By transplanting starts into progressively larger vessels, they do not need to wait for spring to warm the outside soil temperatures.

By germinating seeds early in the year and using grow-lights to control growth, cultivators can determine the sex of their young starts. When the young plants are a couple of months old, cultivators simply cut back the photoperiod from 18 hours of light per day to 12 hours per day. The plants, of course, interpret this as the coming of winter and begin their flowering cycle. Once the plants have revealed their sex, and the males have been identified, the photoperiod is returned to spring. This "sexing" saves the cultivators a lot of work by enabling them to place only female plants in the microclimate system.

*Cutting Starts:* Another popular way of beginning the cultivation cycle is by using cuttings taken from known female plants. (For a discussion of asexual propagation techniques see Chapter 8.) These cuttings provide several advantages for the sinsemilla cultivators.

By taking a cutting from a known female, cultivators know exactly the phenotypic characteristics of the plant. This is extremely valuable to cultivators because it takes the guess-work out of seed selection.

Cuttings provide an excellent method of getting a head start on the cultivation cycle. Cutting starts are at least two to three months older than seed starts. Consequently, they will mature much faster, enabling cultivation in even the higher latitudes of the United States.

Figure 38:
SEED START

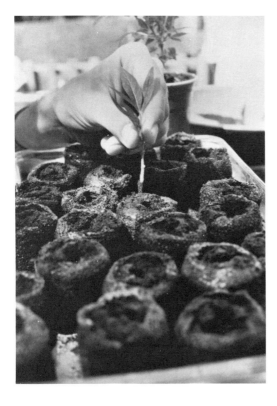

Figure 39: CUTTING START

Cuttings provide a way of growing the most productive part of the cannabis plant—the flowering branch ends. In addition, cutting growth is characteristically dwarfed. This dwarfed growth is easier to conceal than is a 20 ft. tall plant grown from seeds.

The disadvantage of cuttings is in their lack of genetic diversity. If a cultivator should make 20 cuttings from one plant, these cuttings will all have the same genetic intelligence. If this intelligence is not capable of overcoming certain environmental adversities, like grasshoppers, then all 20 plants will be vulnerable to hungry grasshoppers.

In the past several years, an interesting development has occurred with respect to starts. Certain indoor cultivators with a knack for using lights began specializing in making starts for outdoor cultivators. One operation consisted of a husband and wife team. While the wife stayed home with the family and made starts from their collection of Afghani hybrids, the husband made deliveries around the countryside.

This couple provided an extremely valuable service for outdoor cultivators. By purchasing mature female cuttings which were several months old, outdoor cultivators did not have to start their cultivation cycle until late spring. In addition to this head start, they were assured of not having any males to contend with in the autumn.

# Chapter 7

# Vegetative Growth

From the time a young plant is capable of sustaining continuous and uninter-rupted growth until the flower primordium appear, the plant is considered to be in a vegetative growth cycle. This cycle is also called "green-growth" because of the rapid development of chlorophyll-bearing leaves.

Appearances notwithstanding, vegetative growth is not a continuous process, but rather a process of arrested development. Within two months of germi-nation, an annual plant like cannabis becomes capable of producing flowers. Because these flowers enable plants to reproduce, they are an indication of maturity. The flowering response of mature plants is determined by environ-mental conditions (i.e., decreasing photoperiod of light and cooling tempera-tures) to which the plant is exposed. Until such time as these conditions permit, the flowering response is suppressed, and plants continue their vegetative cycle of growth.

When conditions are favorable (i.e., increasing photoperiod of light and warming temperatures) green-growth is characteristically intense. With each new leaf, the plants' ability to produce more leaves increases proportionately. At the peak of the vegetative cycle, cannabis plants might grow over two inches per day. The rate and duration of vegetative growth determine how many flowers plants will produce when environmental conditions initiate their reproductive cycle.

Sinsemilla cultivators have become proficient at increasing both the intensity and duration of vegetative growth. Two basic techniques are employed: First, cultivators improve environmental conditions to which plants are exposed. Second, cultivators improve the physical growth characteristics of the plants.

## IMPROVING ENVIRONMENTAL CONDITIONS

Sinsemilla cultivators improve environmental conditions by controlling and regulating their microclimate systems. While I have covered this aspect of culti-vation in Part 3 of this text, I would nonetheless, like to illustrate how these systems are put into effect.

Each day's growth increases plants' ability to process elements from the

104

Figure 40:
*INDICA* LEAVES
(Vegetative Cycle)

Figure 41:
*INDICA* PLANT
(Vegetative Cycle)

105

environment into new plant tissue. This ability is defined by the number and size of leaves, the extent of root development and physical health. For example, when plants are juvenile seedlings, their capacity might be limited to processing diffused sunlight and small amounts of water. When mature plants are at the peak of growth, their capacity might enable them to process sunlight from the hottest day of the year, and several gallons of water.

To compensate for this expanding capacity, cultivators continually adjust their microclimate systems to increase the availability of elements for growth. With each day's new green-growth, cultivators add more light, water, temperature and nutrients. This increased capacity, together with the increased availability of elements, increases the rate of the vegetative growth cycle.

By improving environmental conditions, cultivators also extend the duration of the vegetative cycle. As mentioned, flowering response is initiated when plants sense the coming of winter. When conditions remain favorable into the late summer, plants continue building new green-growth until the evidence becomes indisputable.

This environmental control enables cultivators to enhance vegetative growth significantly. For example, a plant cultivated under normal practices might reach five feet in height and produce flowers only on the top few branches. On the other hand, that same plant, when cultivated under the intensity of the sinsemilla technique, might grow to three times that height and produce flowers from the top to the bottom (see color plate #31).

This benevolence requires a good deal of sensitivity on the part of cultivators. Each day, the plants' growth requirements must be fulfilled by regulating the microclimate systems. If a cultivator misjudges these requirements, or fails to correctly adjust the system, growth is adversely affected.

Some cultivators are more sensitive than others. This attention to detail is always manifest in the growth of plants. Often cultivators become a little too anxious for more growth and, to encourage the process, make large applications of nitrogen fertilizers. This anxiety can easily result in toxic overdoses, in which case plants shrivel up and die (see figure #44).

With a good deal of sensitivity the vegetative cycle often becomes a process which resembles, in character, a race to a finish. I visited one couple who were especially sensitive in this respect. Their garden was located in a populated area of the Pacific Coastal Range near San Francisco. They had recently transplanted mature female cuttings (vegetative cycle) into the chaparral on a south-facing slope.

As I shot photographs and asked questions, they fertilized their plants with a topsoil dressing. I asked them what they were using for fertilizer, and their response went something like this: "At this time of year (summer solstice) we are encouraging our plants to grow more leaves and branches. Our fertilizer mix contains some blood meal, cotton seed meal, and fish meal. These are sources of nitrogen which become available at different rates. Blood meal is very hot. You

106

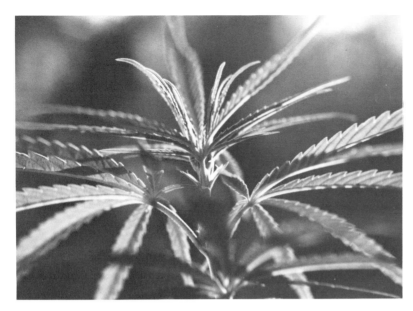

Figure 42:
*SATIVA* BUD
GROWTH
(Vegetative Cycle)

Figure 43:
*SATIVA PLANT*
(Vegetative Cycle)

107

have to watch that stuff or it will burn your plants. We also have a little bit of wood ash, which is an excellent source of potash. Potash makes the stems strong. And to stimulate root growth we have some rock phosphate. For trace elements we used kelp meal, and to sweeten everything up we included a little bit of dolomite lime."

## MANIPULATING VEGETATIVE GROWTH

Cultivators also enhance the vegetative cycle by manipulating the physical growth of the plants. Cultivators manipulate growth to increase the plants' exposure to radiant energy, provide seclusion and promote plant health. I have included a few examples of these physical manipulations to illustrate this "laying on of hands" method of cultivating plants.

*Transplanting:* To extend the duration of the cultivation cycle, cultivators often employ small containers for their starts. (As a matter of fact, I cannot recall meeting one person who started plants in the ground.) These small containers can be kept indoors and protected from the adversities of inclement weather. When spring arrives outdoors, these starts are often transplanted into larger containers and placed outdoors. Because of the illicit nature of cannabis cultivation, plants may be transplanted and translocated several times before being placed into the ground.

*Topping:* Topping is a method of altering the physical symmetry of plants.

108

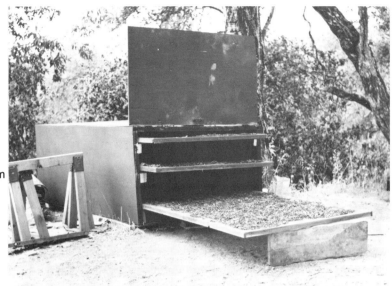

Figure 45:
DRYING BOX
This facility was used for drying leaf and bud "shake" culled from growing plants.

By pinching off the new growth at the end of stem and branches, tall thin plants can be forced into growing short and bushy. In addition, topping also serves to increase the number of flowers by increasing the number of flowering nodes on the branches; however, it also reduces the size of flowers. The result of topping on flower production is that more flowers are produced which are smaller in size.

*Training:* There are several techniques used in physically training the growth of plants. Because of the extremely strong (hemp) fiber in the main stem, cannabis is especially amenable to being trained. By bending a plant over into an arc and securing it to the ground with a "cordon," vertical growth can be made horizontal (see figure #2). By espaliering a plant against a wall or along a trellis (see figure #4), interior branches can be exposed to the sun. By confining a plant's root system within a small vessel, growth can be dwarfed (see figure #3). These physical manipulations are initiated in the green-growth cycle because growth is most flexible at this time.

*Culling:* Often cultivators cull undesirable plant growth to redirect energy into more desirable growth. In the latter stages of the vegetative cycle, plants develop small spindly interior branches that cultivators call "suckers." These branches do not provide any significant flower production and block sunshine from reaching more productive growth. By removing them, cultivators redirect energy into the more productive growth of primary and secondary branches.

After the large "sun" leaves begin losing their chlorophyll, cultivators often remove them. In culling these old leaves, energy is redirected to new, more vigorous leaves. Leaves which become severely infested with pests or diseases are also culled as a means of directing energy.

In the latter stages of the vegetative cycle, male plants begin the flowering

109

response. This is a momentous event in the cultivation cycle if the plants were not "sexed" prior to the vegetative cycle. Cultivators must remove them before they release their clouds of pollen on the emerging females.

While these trimmings have significantly less THC than mature female flowers, they are valued as a taste of things to come. For that reason, trimmings are processed by slow-dry evaporation in dark, dry locations. (See figures #45-47.) This "shake" is then placed on the market, providing many cultivators with the first income of the cultivation cycle.

The life of the cultivator becomes characteristically more intense with the progression of the vegetative cycle. This intensity quickly becomes evident in an ever-increasing workload and in an ever-increasing vulnerability.

As plants become larger, they require more care and more regulation of micro-climate systems. Cultivators who planned on getting rich by growing a couple

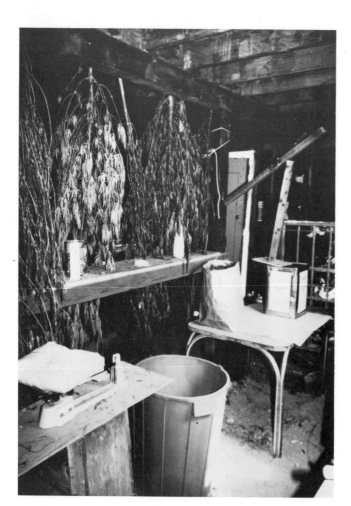

Figure 46:
PROCESSING MALES
Male plants are slow
dryed, cleaned and
packaged as "shake."

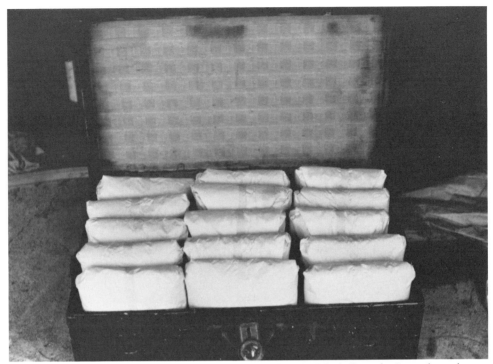
Figure 47: LEAF-PRODUCT Processed male and female "shake" products packaged for market.

hundred plants on the south-forty often find themselves overwhelmed by the amount of physical work required to maintain everything in working order. To compensate, they often hire additional labor to keep things under control—which leads us to vulnerability.

As plants become larger, they become increasingly harder to conceal. In late summer, native vegetation begins struggling against a diminishing supply of elements. Cannabis plants, on the other hand, are likely doing just fine, and exhibit this well-being in very intense green-growth (see color plate #12). Cultivators who did not plan for this eventuality find themselves in an extremely compromising position, and must rely on luck to see themselves through.

These aspects of cannabis cultivation often create an intensity which drives many cultivators to distraction. One late summer afternoon, I was shooting 16mm footage in a garden location in the foothills of the Sierras. This garden was carefully integrated into some low chaparral and poison oak—an excellent example of camouflage. The resident cultivator had left me to my work and returned to his nearby house to tend a trash fire he had going in a burn barrel.

Suddenly, the quiet afternoon was shattered by screaming sirens and flashing red lights. Glancing back over my shoulder, I counted seven emergency vehicles surrounding the cultivator's house. They had come to put out the trash fire, and levy a fine and otherwise convince this fellow not to burn trash on "no-burn" days—to which he readily agreed.

111

# Chapter 8

# Flowering Response

As the season progresses toward winter, environmental conditions trigger a crisis in the life of cannabis plants. The most significant of these conditions is the declining photoperiod of light. A pigment system within leaves, called phytochrome, senses this diminishing period of light and causes the leaves to produce a substance called "florigen." This substance is the catalyst for a biochemical change which forces the vegetative growth of leaf, bud and stem to produce the reproductive growth of pistils and stamens and their accessory parts, petals and sepals. This biochemical change is called the "flowering response."

The reproductive growth of cannabis is, in some respects, similar to that of human beings. Male reproductive organs (stamens) are on one plant and female organs (pistils) are on another. When environmental conditions force a flowering response, male organs appear first. By the time female plants emerge from vegetative growth, the male organs are mature enough to release clouds of pollen over the emerging female organs.

Cannabis is a very prolific plant genus. A single, healthy female plant, for example, is capable of producing tens of thousands of seeds in a single season. When the cycle of growth is left to run its course, pollination results in the rapid deterioration of female growth as all of the plants' energy is directed into the production of seeds. Female plants literally starve themselves to death to provide nutrients for their offspring.

Another interesting aspect of female cannabis plants is that they contain the highest concentration of the chemical THC in the resin bracts of their flowers. There does not appear to be any physiological explanation for this occurrence—perhaps it was just a whim of Mother Nature. Because female plants have the highest concentration of THC, they are the focus of the cultivation cycle.

In sinsemilla cultivation, the normal flowering response of cannabis is interrupted by removing male plants. Without their source of pollen, females continue the flowering response by producing dense clusters of female organs.

This technique is simply a re-investment of energy. Instead of expending everything on the production of seeds, cultivators force the females to continue the production of more flowers. As a result of this manipulation, the duration of the female flowering response is extended from one month to as long as three or four months. Judging from cultivator descriptions of this phase of growth

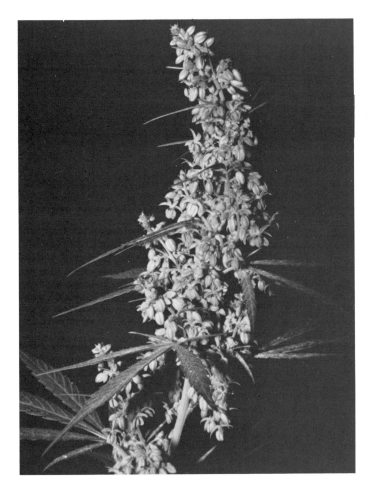

Figure 48:
MATURE MALE
FLOWER DEVELOPMENT

("flowing juices . . . musky scents . . . intense desires, etc.") the condition of these females is definitely X-rated.

While it may seem a simple enough task to remove males from the presence of females, our human experience should tell us that such is not the case. Not only is cannabis prolific, it is also adaptable. Environmental adversities can cause deviant behavior to alter the plants' normal sex life. To cope with these adversities, plants might respond by reversing their sex entirely, or by developing monoecious (hermaphroditic) flowers.

This tendency is seen frequently in cannabis cultivated from seeds imported from Thailand. In that section of the world, cannabis has been cultivated for centuries as a source of THC. As sinsemilla techniques are employed, the cultivar has, over many generations, developed the ability to pollinate itself.

This tendency is not predominant, but rather a deviation from the rule. I bring it up to illustrate how things can get out of hand for sinsemilla cultivators. Consider this notation in the diary of our founding father George Washington (1765): ". . . began to separate the male from the female hemp . . . rather too late."

113

For sinsemilla cultivators, the flowering response is important for two reasons. First, it is the cycle in which the production of flowers is encouraged. Second, it is the cycle in which the characteristics of future generations of cannabis are determined.

## ENCOURAGING FLOWER GROWTH

After male plants have been removed from the garden, sinsemilla cultivators focus their attention on ways of increasing the production of female flower growth. To accomplish this, they merely improve the plants' growing environment by regulating their microclimate systems.

Without a source of pollen, the flowering female plants exhibit many of the same growth characteristics as plants in the vegetative cycle. While they still

Figure 49:
MATURING FEMALE
FLOWER DEVELOPMENT

grow larger with each passing day, growth becomes characteristically more elaborate and dense. In the early phases of this cycle, flower clusters are small and indistinct (see figure #48). To build them into massive "colas," cultivators increase the availability of those environmental elements which affect growth.

Under normal cultivation practices, this regulation of elements would be a difficult task because of the coming of winter. Down in the valley floor, where legitimate crops are nurtured, the autumnal equinox signals the end of cultivation activity for the season. But as cold air masses settle on the valley floor, cultivation activity is becoming even more intense up on the south-facing slopes.

This activity—ironically enough—is made possible because cannabis cultivation is restricted to small spaces. These small spaces can be controlled and regulated in many ways. In the late autumn, this control enables cultivators to continue nurturing their flowering plants well beyond the normal growing season for crops in the valley floor. This late season cultivation activity, of course, is the reason for establishing microclimate systems.

By continuing to provide plants with intense sunshine, warm temperatures, dry air, adequate water and soil nutrients, cultivators encourage their plants to build massive flower clusters. (Most of the cultivators I have interviewed begin using a more balanced supply of nutrients when plants are in flower. That is, they reduce the amount of nitrogen and increase the amount of phosphorus and potassium so that the respective availability of all three minerals is about equal.)

# PROPAGATION

Several times in my travels I met individuals who had sad stories to tell. These tales would go something like this: "I grew some perfect sinsemilla in my backyard. You should have seen those plants. They were just beautiful. But you know, I did such a good job that now I don't have any seeds."

In intensive cultivation, propagation is extremely important because it is the one thing a cultivator can do to insure a future. As a result, cultivators of "seedless" cannabis are often obsessed with propagating new, improved seed strains for future use. For that reason, male plants with favorable characteristics are very important in the overall productivity of the cultivation cycle.

Two basic techniques are used in propagating new cannabis plants. First, cultivators selectively pollinate individual female flowers with pollen "milked" from selected males. Second, cultivators make clonal reproductions of selected females. As both of these propagation techniques require considerable planning, cultivators prepare for this process when plants first enter into flower.

*Asexual Propagation:* To increase the productivity of their microclimate systems, sinsemilla cultivators became proficient in the use of asexual propa-

Figure 50:
MEXICAN
VARIETAL

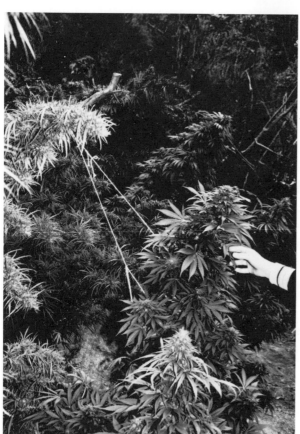

Figure 51:
DWARFED AFGHANI VARIETAL

116

gation techniques. These techniques enable genetic clones to be reproduced from "mother" plants. While there are several methods for producing these clones, by far the most common is the cutting.

Cuttings enable cultivators to preserve the exact genetic intelligence of favored plants. By the time the flowering response begins in early fall, certain plants distinguish themselves as being the best in the garden. These plants always become favorites of the cultivators, and usually are given a name. "Big Bertha" and "Big Mama" are two names I have heard in several different gardens.

To preserve these favorites for the following season, cultivators cut a few inches of fresh, young branch ends which are still in vegetative growth and immediately place them in water. (Should air pockets form inside the stem, the passage of water through the xylem will be blocked and the young cut will wither from lack of water.) These cuttings are then removed from the water, treated with a rooting compound, and placed in a warm, moist soil medium to allow the adventitious roots to develop.

Like every aspect of nurturing plants, taking cuttings requires sensitivity. I have watched quite a few people make cuttings, and each individual seems to have his or her own way of making it work. For example, the individual who provided the cutting for the photograph on the cover of this book works in a technically precise manner. He uses clean razor blades to make the cuttings, then places them into clean environments. These environments, of course, are carefully controlled so that the proper air temperature and moisture content are preserved.

On the other hand, I met a lady up in the Pacific Northwest who employed a different approach. She sat at a large table and cut away with a pair of old scissors. She stuck the young cuts into a medium composed of perlite and vermiculite, dumped water on them and shoved them under the lights. That her method was effective was manifest in the several hundred healthy cuttings around the room in various stages of root development.

The disadvantage of cuttings is that they have no genetic diversity. If the mother plant is vulnerable to a specific pest or disease, then all of the cuttings made from that plant will likewise be vulnerable.

*Sexual Propagation:* In nature, a single cannabis female might be pollinated by dozens of nearby males. This random pollination insures the maximum number of genetic possibilities. In this way, cannabis finds its way in the world.

In cultivation however, females are selectively pollinated for the perpetuation of specific genetic qualities. These qualities might include a high percentage of THC, a short growing season or a distinctive taste and bouquet. Through this controlled pollination, cultivators ensure themselves seeds for next year's crop.

There are two basic approaches to controlled pollination: inbreeding or outbreeding. While these approaches are divergent, they both are predicated on the cultivators' ability to make intelligent selections.

Inbreeding is based on selection from within a single variety. For example, a

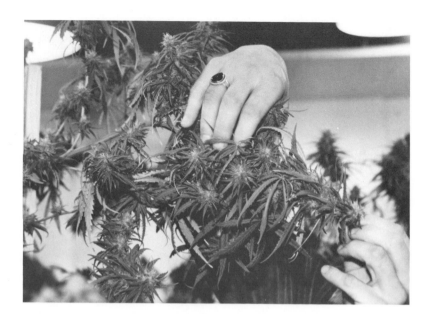

Figure 52:
DOMESTIC
HYBRID
(INDOORS)

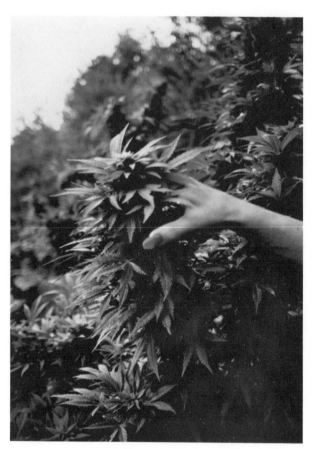

Figure 53:
DWARFED AFGHANI VARIETAL

118

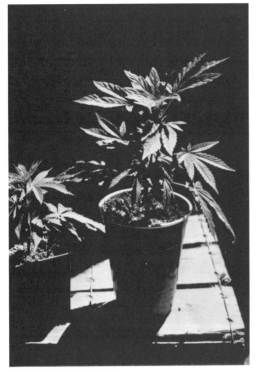

Figure 54:
CUTTING AND TRANSPLANT

Figure 55:
ESTABLISHED CUTTING

cultivator might have a distinctive seed strain from Afghanistan which he wants to preserve in a state as close as possible to the original imported seeds. To maintain this strength, the individual selects the strongest plants for propagation, and by doing so, passes the strength on to the next generation. Inbred seed strains tend to become uniform and bland. To compensate for this tendency, cultivators often breed back and forth across generations.

Outbreeding is based on the selection of genetic intelligence from different varietals. The offspring of this selection are called hybrids. Because of the tremendous number of cannabis varietals imported into the United States, sinsemilla gardens tend to have several different varietals going in the same garden. As a result, most domestic seeds are hybrid combinations of foreign phenotypes.

Hybrids are a genetic compromise between the characteristics of parent plants. The first generation hybrid ($F_1$), however, tends to be larger, healthier and more vigorous than either of the parents. This phenomenon is called "hybrid vigor." To maintain this vigor, cultivators strive to provide new seeds every year. By continually crossing new intelligence into their hybrid strains, cultivators are able to maintain the hybrid vigor every year.

Successive generations of hybrids, on the other hand, often display some of the parents' recessive (and unwanted) genetic traits. Without an intelligent selection process, these traits can become dominant, resulting in another strain of "California No-High."

119

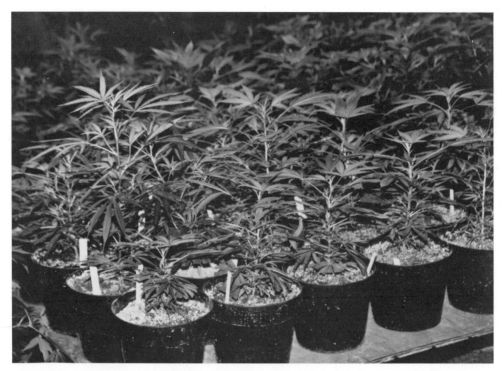

Figure 56: CUTTINGS IN VEGETATIVE CYCLE  In preparation for outdoor growth, these cuttings were subjected to 18 hours of light per day to establish them in a vegetative cycle of growth.

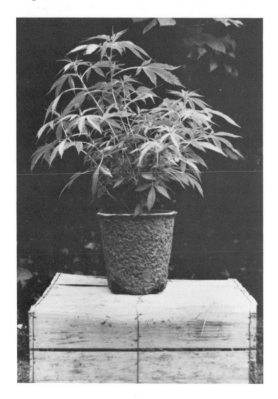

Figure 57:
MATURE CUTTING

This cutting is
ready for either
the vegetative or
flowering cycle.

# Harvest

For city-dwellers, harvest has become synonymous with Thanksgiving. From vague visions of Pilgrim ancestors, a national day of party and pageantry was established to give thanks for the annual harvest. This Thanksgiving is a cheerful day, free of work and worry—a feeling we tend to transpose unto those hard-working individuals who cultivate the soil.

When we consider the sinsemilla harvest, we might imagine it to be a day of Thanksgiving. We might even visualize cultivators' singing happily while "bringing in the sheaves." Such is generally not the case. For sinsemilla cultivators, harvest is more likely a day of fear and near-frantic anticipation.

During developmental phases of growth, cannabis plants have value in their potential to yield THC. Cultivators recognize this potential and devote time and energy in developing it. When plants enter florescence, this potential is realized in THC-bearing female flowers. At this point, the plants have immediate value. As one cultivator expressed previously in this text, "The plants are like trees with $100 dollar bills hanging from the branches."

In addition, florescent plants also become more visible. In outdoor environments, this visibility is compounded by the senescent growth of native vegetation. While cannabis plants become increasingly more vibrant with care and nurturing (see color plate #13), native plants become pale in response to the coming of winter. For cultivators, the visibility of florescent plants is synonymous with vulnerability.

Indoor environments also become increasingly more vulnerable as plants mature. When young, plants transpire only small amounts of water; at the peak of florescence, plants not only transpire a tremendous amount of water but also emit a distinctive bouquet. As a result, cultivators must replace fragrant, saturated air through ventilation. The aroma of this ventilated air wafting through the neigh-

Figure 58: RIPPED-OFF Thieves take the most mature flower clusters and leave the immature growth for the cultivators.

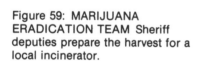
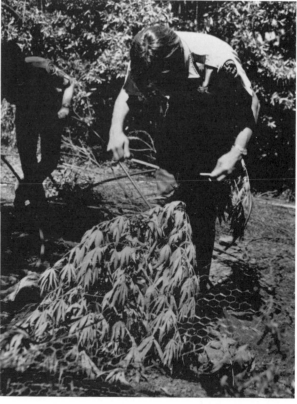

Figure 59: MARIJUANA ERADICATION TEAM Sheriff deputies prepare the harvest for a local incinerator.

122

borhood increases the vulnerability of indoor microclimates.

The more cannabis plants grow and produce, the more valuable they become. The more valuable the plants, the more vulnerable they become. For sinsemilla cultivators, this growth becomes manifest in an ever-increasing state of emotional intensity. Florescence, after all, is the season of the bust and the rip-off.

Often cultivators fail to plan this growth into their production schemes at the beginning of the cultivation cycle. Perhaps they simple failed to plan for the senescent growth of native vegetation. More likely, however, they were just so proud of their growing young plants that they just had to show a friend or two. At any rate, by failing to adequately resolve the cultivators' dilemma, they exposed themselves to the emotional pandemonium of the bust or the rip-off.

Of these two catastrophes, the easier to comprehend is the bust because it is simply the manifestation of confrontation. When plants enter florescence, Marijuana Eradication Teams gather intelligence through a variety of means, then go out into the countryside to eradicate illicit gardens. (See figures #59 and 60.) These teams are charged with the responsibility of keeping illicit activity from getting out of hand, and perform an important responsibility to their community.

I was given a good illustration of this responsibility while accompanying an Eradication Team on a bust in California's rugged Big Sur. The team's first task for the day was to bust a series of small gardens which had been located by the Eye-in-the-Sky. The deputy in charge of the raid explained the significance of what we were to do: "This bust is important for us because we know that one of these people set the big Marble Cone fire earlier this year. We found his chainsaw and a plot of sinsemilla at the point of ignition."

Marijuana Eradication Teams, at least, play by the established rules of confrontation. For the most part, sinsemilla cultivators accept the catastrophe of a bust as being part of the gamble. In addition, law enforcement keeps the prices high by restricting supply. As a result, one rarely finds cultivators who, when candid, will admit to wanting to see the end of Prohibition.

Thievery, on the other hand, is another story. In this disaster, there are no rules. I experienced an example of what can happen in the case of a rip-off while visiting a communal-sized garden in California's Pacific Coastal Range. Four of us sitting in the dark of a late autumn night. It was cold and there was no fire. As a bottle of Canadian whiskey was passed from hand to hand, their story emerged.

When the earliest varietals in the garden matured, thieves came into the garden one night and took all of the mature flower clusters and carried them away. (See figure #58.) To save the rest of their crop, this community of friends had to regroup along the lines of a military post under attack. To accomplish this reorganization, a veteran of the Viet Nam war was brought in. He made specific changes, which included the addition of dogs, field telephones, and combat drills.

In addition, trip lines were strung through the forest and attached to mercury switches. When the trip-lines were disturbed, the switch would complete a circuit and a bell would ring in the garden. I asked if the security measures worked. One

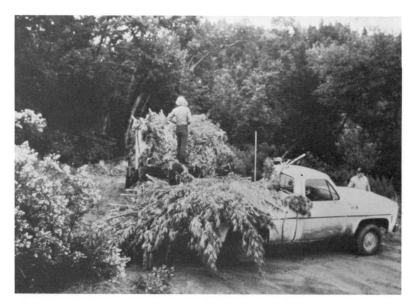

Figure 60: A "LOST DUTCHMAN" HARVEST (Photograph by California Attorney General's Office.)

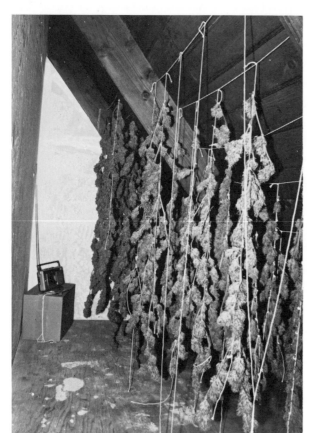

Figure 61: SLOW-DRY To preserve cannabis flowers, excess moisture is slowly evaporated back into the atmosphere.

124

cultivator responded, "You bet they work. The other night we had an alarm and responded by going into our security formations. Then we made a sweep of the woods with our dogs but didn't find anybody. But the next morning we found one of our mercury switches busted."

I asked what would happen if they caught the thieves, another cultivator responded, "We don't want to catch the thieves. We don't even want to know who they are. You see, if we find out, what do we do then? They can call the police, or blackmail us and we would lose our crop. So we act real mean, but inside we're scared shitless."

This emotional intensity is an intrinsic element in the cultivation of cannabis. To one extent or another, every cultivator, and every garden, experiences the stress of this emotional trauma. Individuals who failed to plan for this eventuality when the plants were small seedlings must pay the price when the plants are large and valuable. In a few cases, the price has been paid with a life.

And so, after months of carefully nurturing plants through adversities, cultivators are likely to experience strong emotional reactions during harvest. Rather than celebrating the day in boisterous pageantry, cultivators will more likely work in whispers and tread softly so as not to step on any dry twigs. Because they have so much invested, harvest is a day of fearful reverence—a day not unlike what our Pilgrim ancestors must have experienced so many years ago, for they, too, were outlaws living in a hostile and unforgiving world.

## FLORESCENCE

Cultivators extend the reproductive cycle of cannabis for several months in order to build the weight and character of flower clusters. Each plant in the garden matures at a rate governed by genetic intelligence. To obtain the maximum amount of value, cultivators harvest each plant at the peak of its reproductive cycle. The timing of harvest, therefore, is determined by cultivators' interpreting the life cycle of individual plants.

The most common indicator used in making this evaluation is the state of individual flower development. At the peak of florescence, all but the oldest of flowers have white pistil development. When florescence begins to wain, these white pistils turn brown and begin to wilt. Another indicator is bouquet. When a plant is at the peak of florescence, it has a sweet and musky fragrance. Later, it loses the sweetness.

To evaluate these indicators, cultivators spend a lot of time "laying on the hands." (See figures #50 through 53.) In this respect, cultivators are like master winemakers, pacing up and down the rows of grape vines while watching and waiting for just the right moment to harvest.

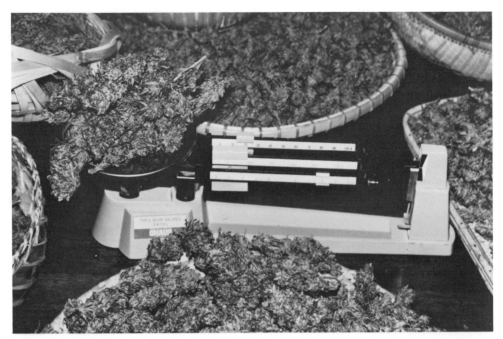

Figure 62: SCALES

Figure 63: FINISHED PRODUCT: Because of their value in the marketplace, cannabis flowers often come in small packages. While these packages contain only one ounce of sinsemilla flowers, they sell for about the same price as an entire pound of imported Columbian cannabis.

126

## HARVEST TECHNIQUE

Sinsemilla cultivators employ one of two techniques in harvesting their plants. The selection of technique is determined by—among other things—the cultivators' emotional state, security status of the garden and weather.

*Selective Harvest:* When environmental conditions are favorable and everything else well controlled, cultivators selectively harvest individual flower clusters as they ripen and mature. The rate at which flowers reach their peak of growth is determined by their position on the plant. Flowers on the top branch ends mature first. By harvesting these mature clusters, cultivators enable the less mature interior flowers to develop body and character. (See color plate #32.)

*Harvest and Run:* When conditions get out-of-control, or adverse weather is imminent, cultivators find themselves in the position of having to harvest and run. Under these circumstances, the prime consideration is expediency—whatever works in the least amount of time is best. Cultivators might cut the plant at the base of the stem or just pull the plant up by the roots (see color plate #34), then run.

## PROCESSING

Once harvested, certain forces which act upon flowers are degenerative in nature. Light, heat, oxygen and mishandling diminish THC content and reduce the qualities of taste, bouquet and appearance. To compensate for these degenerative forces, cultivators perform a four-step process which protects flowers for extended periods of time.

*Cleaning and Manicuring:* Manicuring is a process of separation. Flower clusters are first separated from leaves, branches and stems. Then these flower clusters are separated into different grades, with the top clusters in one grade and the inferior bottom clusters in another. Cultivators usually label the top clusters "NFS" (Not For Sale). In addition, cultivators use this separation process to search for seeds hidden within the dense flower clusters.

Cleaning and manicuring are labor intensive endeavors taking many hours of time. Cultivators often hire friends to help; consequently, the process resembles an old-fashioned corn husking as they all sit and "snip until they flip."

*Drying:* To prepare the flowers for consumption, excess water must be evaporated. The method used for evaporating water is the same as that used for drying other herbs and spices. The flowers are hung upside down in a dark, dry and well-ventilated space. Cultivators assert that the slower evaporation processes result in sweeter tasting products. As the water evaporates, the thick

coating of resin becomes even thicker and forms a natural sealant. When about 90% of the water is evaporated, the flowers are removed from the drying room.

*Packaging:* To protect the dried flowers for extended periods of time, cultivators package them in airtight containers. The best containers for packaging are glass jars, but plastic containers, stoneware and vacuum-sealed "boilable" plastic pouches (see color plate #36) provide reasonable alternatives. Said one cultivator about his packaging practices, "I get $3,000 dollars a pound for my homegrown. The reason I get this much is because my product is the best. I use only organic soil nutrients for the plants and slow-dry the flowers for two to three weeks. I spend months growing these plants, so when they are ready for packaging, I put them in glass jars. My people expect the best."

*Storing:* A stash of beautifully dried and manicured flowers lying around the house provides the ultimate temptation to thieves. It is one commodity that has no serial number, nor is the potential victim likely to call the police for help. To avoid problems of this sort, cultivators must find suitable storage locations elsewhere. One ingenious individual resolved this dilemma by hiring a meat locker at a local packing plant. This cold storage provided suitable security and preserved the character and potency of his harvested flowers.

## END OF CYCLE

Ten years ago, dealers sold imported cannabis for $10 an ounce; today, cultivators sell cannabis grown from those imported varieties for $10 a gram. This increase in value resulted from two forces acting upon the phenomenon of cannabis. First, Prohibition has restricted the movement of cannabis in the United States, thereby reducing supply. Second, cultivators here in the United States have learned how to produce more cannabis of higher quality by growing fewer plants in smaller spaces.

The significance of domestic cultivation is profound. This underground industry has been called the number one crop here in California, which is the number one agricultural state in the nation. But its importance may extend beyond providing illicit herbs to the consuming public

Sinsemilla cultivators, for the most part, are individuals generations-removed from the ways of the soil. Yet these individuals are capable of cultivating crops in incredibly adverse environments. It takes a good deal of ingenuity and dedication, for example, to grow a plant from the high deserts of Afghanistan in the environment of a closet in Missoula, Montana. Today, this intelligence is dedicated to cultivating an illicit herb. Tomorrow, it could well be employed in the cultivation of food on small parcels of land.

# Color Photograph Notes

**Plate 1**  SEED BANK: One of the more important aspects of cannabis cultivation is the genetic heritage (or genotype) of seeds. This cultivator's collection of seeds represents several hundred genotypes from around the world. He has many possibilities from which to choose.

**Plate 2**  COLOR—CODED: These young female cuttings were placed in colored plastic cups so that the cultivators could keep track of their respective genotypes.

**Plate 3**  COMPANION PLANTING: In this greenhouse environment, the cultivator enjoyed a varied pursuit by growing vegetables and flowers along with cannabis. When I visited later in the year, however, the cannabis plants had pretty much taken over.

**Plate 4**  HOLE GARDEN: Early in the spring, the backyard fence was sufficient to hide these plants. As the season progressed, however, the cultivators found it necessary to raise the level of the fence, so they dug a deep hole.

**Plate 5**  LIGHT FOR SEEDLINGS (photo by S. Murray): To extend the length of the growing season in northern latitudes, cultivators often start their plants under lights in the deep of winter. When spring arrives, these plants will be several months old.

**Plate 6**  GREENHOUSE IN WINTER: The cycle of cultivation follows the seasons of the sun. In winter, when the sun is low in the southern skies, cultivation activity consists of preparing for the coming of spring. (Note last year's cannabis stem leaning against the soil bed in the center of the photograph.)

**Plate 7**  VERDANT SLOPE: For many reasons, sinsemilla cultivators prefer the steep slope as an environment for their plants. Note how individual holes have been prepared for each plant.

**Plate 8**  VESSELS IN SLOPE: To conceal the characteristic vivid green of cannabis growth, this cultivator dwarfed these *Cannabis indica* plants by confining them to paper vessels, then inserting the vessels into the dense cover of a steep south-facing slope.

**Plate 9**  PRODUCTION LIGHTROOM: This environment was concealed in the basement of a rather ordinary looking house in the Pacific Northwest. The lights are high-intensity 1000 watt metal halide lamps, and the plants are *Cannabis indica* (Afghani) cuttings.

**Plate 10**  OLD BARN FARM: This cultivator employed an old dilapidated structure near his home to conceal the growth of potted *indica* cuttings. To increase solar exposure, he had removed a portion of the old roofing.

129

**Plate 11**  SECRET GARDEN:  While cultivators struggle to conceal the growth of their cannabis plants, they must also struggle to provide them with solar energy. As a result, the plants have a way of shining through even the best of cover. Note cultivator tending plants in center of photo.

**Plate 12**  GREEN GROWTH:  When the plants are small, they are easily concealed. But as the season progresses, and the growth of native vegetation slows for want of water, the cultivated cannabis plants shine in the sun.

**Plate 13**  FLORESCENCE:  At the peak of their flowering cycle, these intensively cultivated *Cannabis sativa* plants are vibrant with energy. Some cultivators claim that if they are quiet enough, they can hear the plants grow.

**Plate 14**  FIELD TEST:  Sinsemilla cultivation is often characterized as being hard work. Cultivators spend many hours pruning, watering, feeding and otherwise caring for their plants. As with makers of fine wine, they often pause in their labor for a little taste test. It is their way of paying attention, so to speak.

**Plate 15**  GARDEN SHOOT:  This shoot occurred in one of the more remote areas of Mendocino County. The garden—the bright splash of green in the center of the photograph—was concealed between a large cliff and the shimmering waters of a river. As it was one of the better microclimates I had ever seen, I included it in this collection. (Photograph by Mrs. Kayo.)

**Plate 16**  GARDEN SENTRY:  Sinsemilla cultivators are particularly vulnerable to thieves. If the garden is threatened by thieves, there is no government agency to call for help. To protect themselves, cultivators often have a good dog or two around.

**INFRARED PHOTOGRAPHY NOTES:**  In shooting the illicit cannabis plants, I faced a basic dilemma.

To avoid detection and prosecution, sinsemilla cultivators conceal their plants as best they can within the context of native environments. As the forces of Prohibition improved in the detection and destruction of these illicit plants, cultivators likewise improved in their ability to conceal them. As a result of this confrontation, I found myself shooting photographs of plants which, when the film was processed, would appear as indistinct splotches of green.

To resolve this dilemma, I resorted to using infrared sensitive film. Unlike regular color film, which has three emulsion layers sensitive to blue, green and red radiation, infrared film has three emulsion layers sensitive to green, red and infrared radiation. By using this infrared sensitive film, one can record energy from the visible spectrum as well as energy from the invisible infrared spectrum.

While infrared radiation is not visible to the eye, its frequency spectrum is nearly as broad as that of visible light. As a result, it is the source of much information. In the context of these photographs, I used infrared film to measure the luminescence of growing plants.

Luminescence is the emission of light created by the plants' physiological processes. Infrared sensitive film therefore, is a way of measuring the metabolic activity of growing plants. Healthy, rapidly growing plants appear vivid red, while unhealthy, struggling plants appear dull red, green or brown. As they emit no energy, dead plants appear grayish white.

To increase productivity, sinsemilla cultivators feed, water and otherwise care for

130

their plants so as to insure their maximum rate of metabolism. As a result, the plants appear vivid red when captured with infrared film. In contrast, the surrounding native vegetation must struggle with those elements of growth which mother nature provides. In the autumn, this growth is characteristically very slow; consequently, when these native plants are captured on infrared film, they are characteristically dull red or white.

By using this infrared sensitive film, I was able to separate the highly cultivated cannabis plants from the surrounding vegetation within which they were concealed. In addition, I was able to measure, with some degree of accuracy, the intensity with which these plants are nurtured.

**Plate 17**  DWARF CUTTINGS IN CHAPARRAL: *Cannabis indica* cuttings concealed in the dense growth of chaparral are revealed as a sharp band of red running through photograph from left to right.

**Plate 18**  KODACHROME GARDEN: Can you find the cannabis plants? This well-camouflaged garden was extremely hard to see even while standing in the middle of it. Note the kneeling figure (center right).

**Plate 19**  INFRARED GARDEN: The well-nurtured plants (courtesy of kneeling figure) are revealed as bright patches of red. Note the lusterless growth of the native vegetation.

**Plate 20**  GARDEN ENTRANCE: This stand of *indica/sativa* hybrids was concealed in a lush stand of oak and madrone. Note the sculpted image standing watch at the garden entrance.

**Plate 21**  PLANTS, VESSELS and SLOPE:  These plants were dwarfed by having their root systems confined to paper vessels. Note the intensity of heat being generated by their stems.

**Plate 22**  HARVEST MOON: I shot this photograph in the late hours of an October night. As I conversed with the resident cultivators, a low, fast-moving layer of clouds shot across the full moon, illuminating the night sky. I exposed the plant with a flash, then held the shutter open so that the sky would also expose. The cultivators then told me to quit shooting flashes in the garden, "We don't want all the neighbors to wonder what's going on. Ya know."

**Plate 23**  *CANNABIS SATIVA:*

**Plate 24**  AERIAL PERSPECTIVE: Can you find the sinsemilla garden down there? It is the pattern of small green dots in the center of the photograph. This is how large gardens appear to the Eye-in-the-Sky.

**Plate 25**  GARDEN PERSPECTIVE: Can you find the Eye-in-the-Sky in this photograph? Marijuana Eradication Teams prefer to use slow-flying, high-winged aircraft because they provide the best platform from which illegal activity can be monitored.

**Plate 26**  KODACHROME PLANT: Even with the surrounding vegetation dying back, this *indica/sativa* hybrid is well camouflaged.

131

**Plate 27**  INFRARED PLANT:

**Plate 28**  NIGHT WATCH: I shot this photograph as the lady disappeared into the garden for her evening watch. The last rays of the sunshine illuminated her hair and shirt, then she was gone.

**Plate 29**  HARVEST RAIN: In the late autumn, when the plants are heavy in flower, rain adds weight the plants cannot tolerate. Later they will dry out and stretch for the sun again.

**Plate 30**  GARDEN AND SHELTER: While the mature plants are still "in the ground," cultivators often build themselves temporary shelters and stay in the garden to ward off thieves.

**Plate 31**  CAMOUFLAGE MAN AND *CANNABIS SATIVA:* Cultivators must conceal their activity within the garden as well as the growth of the plants. For that reason, they often don "cammys." Note the soil dike built around the base of the plant.

**Plate 32**  SELECTIVE HARVEST: When the cultivators' situation is well in hand, they often harvest only the most mature flower clusters, leaving the immature flowers to grow and build weight.

**Plate 33**  *CANNABIS INDICA* AND *CANNABIS SATIVA:* This particular garden had a row of *indica* varietals growing beneath a row of *sativa* varietals. Note the decaying leaves on the ground.

**Plate 34**  OUT-OF-THE-GROUND:

**Plate 35**  VARIETALS: The varietal on the left is *Cannabis indica,* while the one on the right is a *sativa/indica* hybrid. Note the differing infrared radiation being emitted.

**Plate 36**  STASH: While shooting this individual's stash of homegrown sinsemilla, I asked for an object to place next to the flowers to denote size. He laid this Smith & Wesson 44 on the table and said, "Insured by . . . ."

**Plate 37**  THANKSGIVING: Having survived a cultivation cycle, sinsemilla cultivators become notoriously proud of their homegrown product, and often build little displays to show it off.

**Plate 38**  KATYDID:

**Plate 39**  *INDICA* FLOWER: This "colita" is a late season flower from an Afghani varietal of *Cannabis indica.*

**Plate 40**  *SATIVA* FLOWER: This "colita," for one reason or another, is deficient in chlorophyll. These little "glitches" in the overall appearance of plants are called "sports."

132

134

# THE SINSEMILLA TECHNIQUE
## by Kayo

## FOR ADDITIONAL COPIES:

Send $19.95 + $3.00 handling (first class) to:

**The Last Gasp of San Francisco**
**P.O. Box 212**
**Berkeley, California**
**94701**

---

## ORDER FORM:

Enclosed is my personal check _____ / money order _____ for _____ copies of *The Sinsemilla Technique*, by Kayo.

Name _____

Address _____

City/State/Zip _____

---

## ORDER FORM:

Enclosed is my personal check _____ / money order _____ for _____ copies of *The Sinsemilla Technique*, by Kayo.

Name _____

Address _____

City/State/Zip _____

---

- Orders must be paid by check or money order payable to The Last Gasp of San Francisco. For orders paid by personal check allow an extra two weeks for bank clearance.

# THE SINSEMILLA TECHNIQUE
## by Kayo

## FOR ADDITIONAL COPIES:

Send $19.95 + $3.00 handling (first class) to:

**The Last Gasp of San Francisco
P.O. Box 212
Berkeley, California
94701**

---

## ORDER FORM:

Enclosed is my personal check _____ / money order _____ for _____ copies of *The Sinsemilla Technique*, by Kayo.

Name _____

Address _____

City/State/Zip _____

---

## ORDER FORM:

Enclosed is my personal check _____ / money order _____ for _____ copies of *The Sinsemilla Technique*, by Kayo.

Name _____

Address _____

City/State/Zip _____

---

- Orders must be paid by check or money order payable to The Last Gasp of San Francisco. For orders paid by personal check allow an extra two weeks for bank clearance.